Ideals of Beauty

Thames & Hudson world of art

This famous series provides the widest available range of illustrated books on art in all its aspects. If you would like to receive a complete list of titles in print please write to:

THAMES & HUDSON
181A High Holborn
London WC1V 7QX

In the United States please write to:

THAMES & HUDSON INC.
500 Fifth Avenue
New York, New York 10110

Printed in Singapore

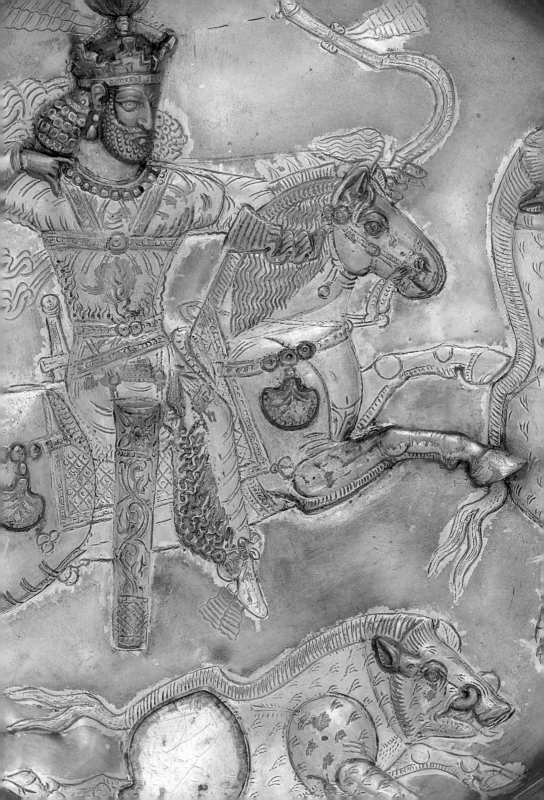

Ideals of Beauty

ASIAN AND AMERICAN ART
IN THE FREER AND SACKLER GALLERIES

Smithsonian
*Freer Gallery of Art and
Arthur M. Sackler Gallery*

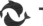 **Thames & Hudson** world of art

Preceding these pages:
Plate (detail)
Iran, Sasanian period, 300–400
(See page 49)

On pages 14–15:
Inkstone box with scene from *The Tale of Genji* (detail)
Japan, Edo period, 17th century
(See page 152)

On pages 174–75:
Harmony in Blue and Gold: The Peacock Room (detail)
James McNeill Whistler, 1876–77
(See pages 23–25)

Please note that not every object in this book will be on display at all times.

"Moving Forward" adapted and reprinted with permission from the January/February
2006 issue of *Arts of Asia*, www.artsofasianet.com

First published in 2010 in paperback in the United States of America
by Thames & Hudson Inc., 500 Fifth Avenue, New York, New York 10110

thamesandhudsonusa.com

ISBN 978-0-500-20403-0
Library of Congress Cataloging-in-Publication Data

Ideals of beauty : Asian and American art in the Freer and Sackler
galleries.
 p. cm.
 Includes index.
 ISBN 978-0-500-20403-0 (pbk.)
 1. Art, Asian--Catalogs. 2. Art, American--Catalogs. 3.
Art--Washington (D.C.)--Catalogs. 4. Library materials--Washington
(D.C.)--Catalogs. 5. Freer Gallery of Art--Catalogs. 6. Arthur M.
Sackler Gallery (Smithsonian Institution)--Catalogs. I. Title: Asian
and American art in the Freer and Sackler galleries.
 N7262.I33 2010
 709.5'074753--dc22
 2009027931

Printed and bound in Singapore by CS Graphics

Contents

Moving Forward

Julian Raby, Director

The Freer Gallery of Art and the Arthur M. Sackler Gallery—what a concatenation of names! It makes for such an unmanageable mouthful that the staff has resorted to abbreviations: "Freer & Sackler," plain "Freer" or plain "Sackler," or in this era of sound bites, the acronym "FSG." Yet much can lie in a name, and in this case the full title, though ponderous, reflects an interesting history in which we can trace the strength of our tradition and the potential for the future.

A Gift to the Nation

Charles Lang Freer at his Detroit home in February 1909, next to one of his Egyptian bronzes and a work called Resting *by James McNeill Whistler.*

OPPOSITE
*North corridor,
Freer Gallery of Art.*

In 1906, the Smithsonian Institution Board of Regents accepted Charles Lang Freer's offer to give to the American people his already substantial collection of American and Asian art. The gift was to be accompanied by the building of a prestigious museum in Washington, D.C. Over the next thirteen years Freer's collection grew exponentially, and before his death in 1919, he worked with architect Charles Adams Platt to create an Italianate structure with a porticoed courtyard that to this day remains one of the most elegant museum structures in the world. In terms of scale, proportion, materials, and lighting, the Freer Gallery reveals the same sensitivity to harmony, repose, and contemplation that inspired its founder's taste in paintings and artifacts.

An industrialist from Detroit, Freer was imbued by the ideals of the Aesthetic Movement, and above all by the vision of the American expatriate artist James McNeill Whistler. With the artist's guidance, Freer formed a collection of almost one thousand works by Whistler. Corresponding shortly before Whistler's death in 1903, the two friends remarked on how well formed and, indeed, near perfect the collection had become. It was surely this belief in the integrity of his Whistler collection that prompted Freer to insist on no further acquisitions and that his museum should neither borrow nor loan works of art.

Whistler's influence on Freer extended to concepts of design and display, but the artist also introduced the collector to the arts of China and Japan. Freer amassed a sizable collection of Far Eastern art by 1906, but in the following thirteen years he built on it compendiously. Shortly before his death, he amended his will, granting a select group of close friends the right to make judicious acquisitions for his collection. Since then, the Freer Gallery's successive directors and curators have focused on the arts of Asia, adding many of the outstanding acquisitions that make the Freer Gallery the repository of so many "destination items."

Through the years, the museum has proudly upheld two of the ideals enunciated in the original gift of 1906: beauty and study. Freer's successors have remained true to his demand for objects of quality and at the same time developed an honored tradition of scholarship, maintaining a close link with the University of Michigan; publishing catalogues, a journal, and a monograph series; and founding one of the first conservation and research laboratories specializing in Asian art.

By the last decades of the twentieth century, the Freer's strengths were well established and universally recognized. But the museum's inability to host loan exhibitions and its eschewal of modern and contemporary art meant that it could not keep up with two of the most pressing trends in museums. In short, there was a danger of stasis. And then along came our second founder.

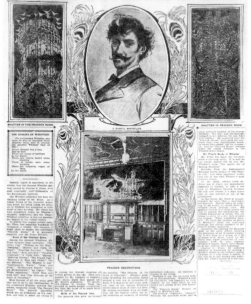

Press coverage of Freer's gift to the nation highlighted the Peacock Room, which traveled from Detroit to Washington, D.C., after the collector's death in 1919.

An Underground Adventure

Arthur M. Sackler formed a business empire built on pharmaceuticals and medical publishing and amassed formidable collections across a diverse range of world art. Thanks to his generosity and foresight, the Smithsonian

was able to create a major complex that included his eponymous museum, the National Museum of African Art, and the International Gallery, as well as offices and public lecture halls. This largely subterranean complex extended the Smithsonian's public offerings particularly in the humanities, but it also greatly expanded the institution's potential for Asian art.

The expansion was one of space and also collections, for Arthur M. Sackler donated a thousand objects of great quality. These complemented the holdings in the Freer, especially in ancient Chinese bronzes and jades and Sasanian silver, but they also added material unrepresented in the older museum. The most important "expansion" was institutional, as the Sackler had none of the Freer's constitutional restrictions against loans—

Main staircase,
Arthur M. Sackler Gallery.

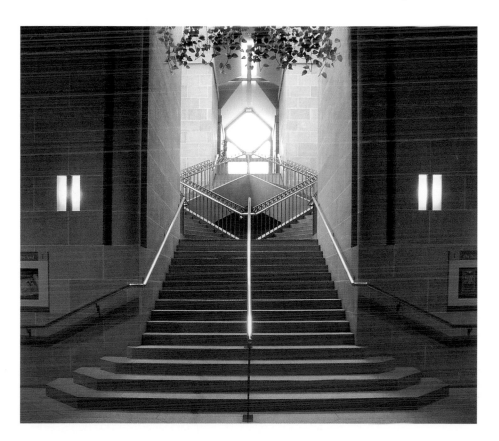

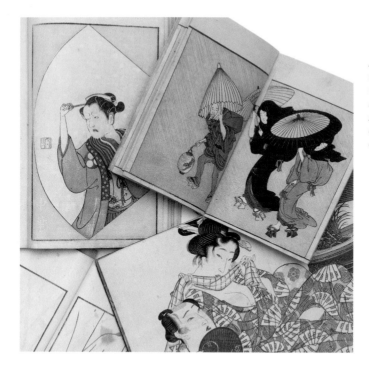

Among the treasures in the Gerhard Pulverer Collection of premodern illustrated books are these scenes of daily life and entertainment in 19th-century Japan.

incoming or outgoing—and none of the historical aversion to modern and contemporary art from Asia.

Looking Ahead

The challenge now is to preserve the Freer's legacy in both the artistic and scholarly realms while building energetically on the Sackler's potential. In fact, the Sackler forms the ideal counterpart to the Freer. The two museums are physically linked and united under a single administration, a single staff, and a single Board of Trustees. Like the two faces of a coin, they are different in appearance but integral to that unit of currency.

One of the most important developments in recent years occurred in October 1999, auspiciously just on the eve of the millennium, when the Regents of the Smithsonian agreed to allow objects from the Freer collection to be shown on a temporary basis in the Sackler. This has enabled us to juxtapose Freer objects with not only those from the Sackler but also from other collections. The benefits of this policy were seen, for example, in the centenary year of 2006, when we presented two major

Seated Buddha
Cambodia, Angkor period,
12th century
Bronze; 30 x 13.2 cm
Freer Gallery of Art,
F1937.29.

international loan exhibitions, one on the Japanese master Hokusai, the other on the development of the Bible as text, canon, and codex. Both were appropriate for the hundredth anniversary of Freer's original gift, as it was Freer who formed arguably the single most important collection of paintings by Hokusai and who, in 1906, purchased a collection of fourth- to sixth-century biblical codices that is still unrivaled in the United States.

Building the Collections

The Freer Gallery of Art has made important acquisitions, including a tenth-century Chola bronze of Shiva Nataraja and a thirteenth-century Japanese sculpture of Amida Buddha. Both objects happen to complement existing strengths, but we are searching always for those destination items that so distinguish the Freer's collections. And in recent years the Sackler has received, for example, two major collections of Japanese prints. From Anne van Biema came some four hundred eighteenth- and nineteenth-century ukiyo-e prints selected with the most discerning eye for quality of impression and condition. From Robert O. Muller came more than four thousand *shin hanga* modernist prints of the first half of the twentieth century. Many of these were acquired directly from the printmakers and publishers with whom Muller and his wife had developed personal friendships. Anne van Biema also established a fellowship program and a munificent endowment for the study of Japanese graphic arts, creating an ideal legacy of artistic resources and financial support.

Rooted in Scholarship

Anne van Biema's funding for research could not have come at a more timely moment. We are concentrating considerable effort on scholarly programs and publications, including our academic monograph series and scholarly art journal *Ars Orientalis*. A major examination of

the Southeast Asian ceramics collection has been launched as a web-based catalogue (http://seasianceramics.asia.si.edu), allowing colleagues around the word to contribute to an ongoing process of identification and classification.

The Way Forward

All of this sounds deadly serious, and in many respects the expense and effort required make that inevitable. But the museums are, and always have been, as much about people as about objects. And we are having a lot of fun. We fold the pleasure into film festivals, music, performing arts, artists' presentations, and the ImaginAsia family programs that bring parents and children into the galleries to encounter works of art. At the same time, we encourage learning through symposia, lectures, curator-led gallery talks, and insightful docent tours. The museums are often packed with visitors of all ages, backgrounds, and levels of familiarity with our collections. All told, we are putting a structure in place to make the Freer and Sackler Galleries—the national museums of Asian art—an inspiring destination for decades and centuries to come.

Adapted and reprinted with permission from the January/February 2006 issue of *Arts of Asia*.

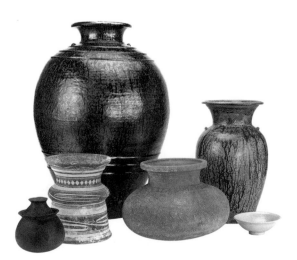

Some of the varied yet highly distinctive jars and bowls in the Hauge Collection of Ceramics from Mainland Southeast Asia.

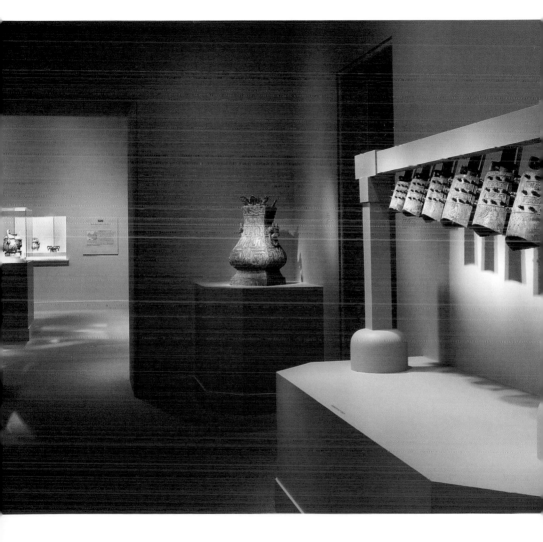

Arts of China galleries, Arthur M. Sackler Gallery of Art. The museums have one of the finest collections of Chinese art outside of China, with more than 10,000 objects dating from Neolithic times (ca. 7000–ca. 2000 BCE) to the present.

the collection

Variations in Flesh Colour and Green: The Balcony

James McNeill Whistler (1834–1903)

1864–70

Oil on wood panel; 61.4 x 48.8 cm

Gift of Charles Lang Freer

Freer Gallery of Art, F1892.23

James McNeill Whistler played an important role in the aesthetic education of Charles Lang Freer, and the juxtaposition of Asian antiquities and nineteenth-century American painting in the Freer Gallery of Art is largely due to the artist's influence. Freer purchased this work, his first oil by the artist, in 1892, the same year he began to collect Japanese prints. Whistler subsequently encouraged Freer to travel to Asia and seek out even more rare examples of Japanese and Chinese art to complement his American artworks, particularly his growing collection of Whistlers. As Freer told John Gellatly, a fellow collector, "Throughout the entire range of Whistler's art… one feels the exercise of spiritual influences similar to those of the masters of Chinese and Japanese art, and of course, Mr. Whistler does unite the art of the Occident with that of the Orient."

A pivotal work in Whistler's oeuvre, *The Balcony* stands between his japonesque costume pictures of the mid-1860s and the fully synthesized approach to Japanese art evident in his Nocturnes—the artist's term for the evocative, nearly abstract images of urban darkness that he produced in the 1870s. Although he never visited Asia, Whistler began to collect Japanese art in the spring of 1863, when he made regular purchases of fans, lacquer, woodblock prints, and folding screens from a shop on the rue de Rivoli in Paris. He was seeking to distance himself from his earlier association with French realism, and Japanese art provided an alternative source of inspiration. *The Balcony*, with its flattened forms, tilted foreground, and kimono-clad models, borrows compositional and thematic elements from ukiyo-e prints depicting Edo-period courtesans. Butterflies link the fantasy of the foreground to the poetically rendered river view beyond, and a stylized red butterfly (derived from Whistler's monogram) on an oblong cartouche is reminiscent of a Japanese artist's seal. While he later eliminated the cartouche, Whistler continued to sign his works with a butterfly emblem, forging a link among his name, his art, and the artists of Japan.

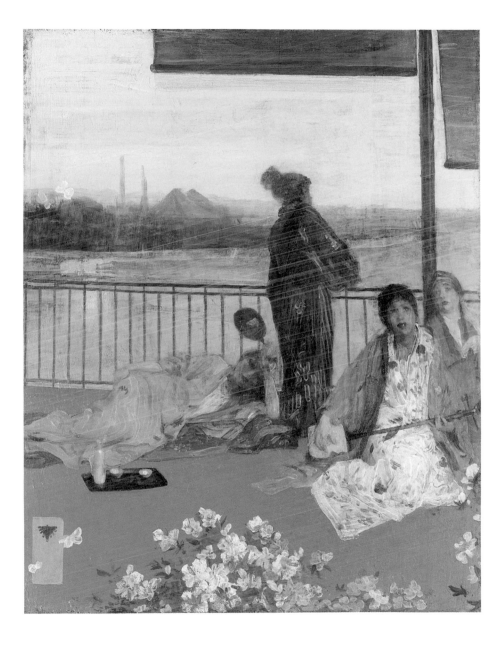

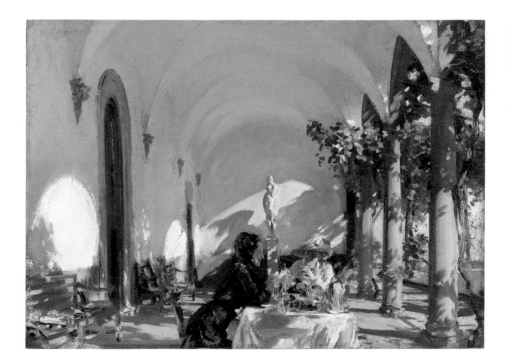

Breakfast in the Loggia

John Singer Sargent (1856–1925)
1910
Oil on canvas; 51.5 x 71 cm
Gift of Charles Lang Freer
Freer Gallery of Art, F1917.182

Though he made his fame and fortune as a cosmopolitan painter of high society, the expatriate artist John Singer Sargent found particular enjoyment in painting small-scale landscapes and genre scenes, and the three works by Sargent in the Freer Gallery belong to this more personal category. *Breakfast in the Loggia* was painted in 1910 during an Italian holiday: Sargent and a group of his friends stayed in the Villa Torre Galli, a picturesque building just outside Florence, where the artist was inspired to paint several "conversation pieces" depicting his traveling companions in the villa's sunny courtyard. In *Breakfast in the Loggia*, Sargent's friends Jane de Glehn and Lady Clara Richmond enjoy a perfect Mediterranean morning; just behind these proper Edwardian ladies and at the very center of the composition is a marble statue of Venus, goddess of love and beauty. The artist's characteristic bravura brushwork brilliantly captures the effects of light and shadow, lending an air of vibrant immediacy to the scene.

The image struck a chord with Charles Lang Freer, who had made a tour of Italian villas and gardens from 1894 to 1895, following an itinerary recommended by architect Charles Adams Platt in his book *Italian Gardens* (1894). More than a decade later, Freer hired Platt to design his museum in Washington, D.C., an Italian Renaissance-style building with exhibition galleries organized around a garden courtyard. For all the *joie de vivre* conveyed by *Breakfast in the Loggia*, its significance for Freer, whose health was seriously failing in 1917, may have been bittersweet: it recalled the past pleasures of his Italian sojourn and anticipated the courtyard of the Freer Gallery of Art, which opened to the public in 1923, nearly four years after its founder's death.

The Four Sylvan Sounds
Thomas Wilmer Dewing (1851–1938)
1896–97
Oil on wood panels; 175.5 x 153 cm (each)
Gift of Charles Lang Freer
Freer Gallery of Art, F1906.72, F1906.73

Writing to Charles Lang Freer from his summer studio in Cornish, New
Hampshire, in 1894, the painter Thomas Dewing observed, "I wish you
could be here, taking in this cool fresh air filled with bird notes & scents
of flowers." Two years later, the artist translated the sensory pleasures of
a woodland ramble into the visual language of painting, noting in a letter
to Freer that he had begun to paint a pair of screens representing "the

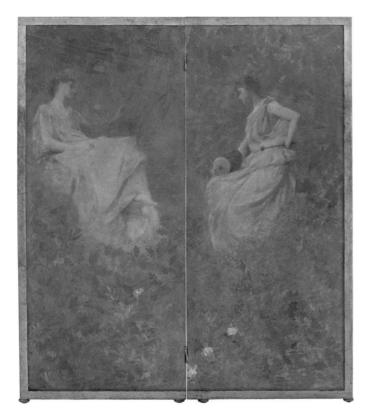

four forest notes—the Hermit Thrush, the sound of running water, the woodpecker, and the wind through the pine trees."

Inspiration for the screens came from a variety of sources, the most direct being the evocative New England landscape. The idea for a bifold screen may have come from the artist's 1895 visit to the Paris studio of James McNeill Whistler, where Dewing had seen a Japanese screen painted with a Nocturne, Whistler's term for his moonlit river views. Dewing knew that the Japanese format appealed to Freer, for he often acted as the collector's agent at Yamanaka & Co., a New York dealer in Asian art. During the two years that Dewing worked on *The Four Sylvan Sounds*, Freer acquired twelve Japanese screens. The influence of those works is apparent here in the forest leaves and flowers, painted with a stencil, which recall the elegant, stylized patterns of several screens in Freer's Japanese collection.

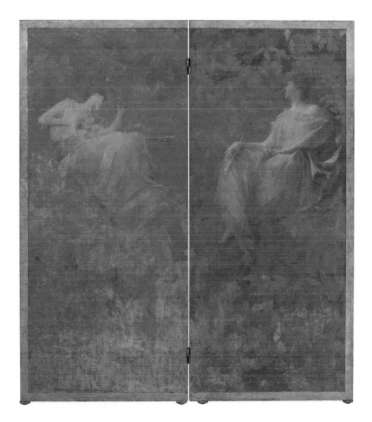

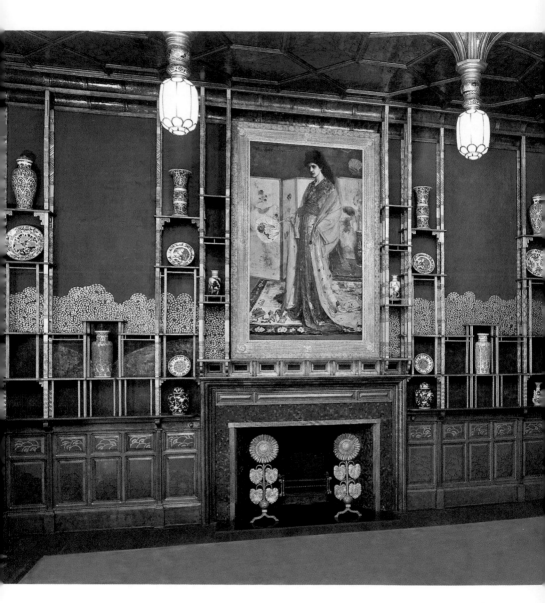

Harmony in Blue and Gold: The Peacock Room
James McNeill Whistler (1834–1903)
1876–77
Oil paint and gold leaf on canvas, leather, and wood;
4.216 x 6.134 x 10.262 m
Gift of Charles Lang Freer
Freer Gallery of Art, F1904.61

The history of *Harmony in Blue and Gold: The Peacock Room* is best understood as a story in two parts. Whistler stands at the center and on either side are his two most important patrons: Frederick Leyland (1831–1892), the shipowner from Liverpool who sought to transform his London mansion into a palace of art; and Charles Lang Freer, the industrialist from Detroit whose collection of Asian and American art formed the basis of the Smithsonian's first art museum.

Leyland had hired Whistler in 1876 to decorate the entrance hall of his townhouse; at the same time the architect Thomas Jeckyll was working in the adjacent dining room, where Leyland displayed his blue-and-white porcelain. A painting by Whistler, *La Princesse du pays de la porcelaine*, hung above the fireplace, so Jeckyll asked the artist's advice about the color scheme of the room. With Leyland's consent, Whistler retouched the walls and decorated the wainscoting and cornice with a wave pattern of blue and gold. Leyland assumed the decoration was nearly complete and went to Liverpool on business.

Meanwhile, Whistler continued to work in the room, gilding and ornamenting the ceiling and decorating the shutters with golden peacocks. He wrote to Leyland, hinting at the "brilliant and gorgeous" surprise awaiting him. He also entertained visitors and newspaper reporters, who published amusing accounts of Whistler's antics. When Leyland saw the room, its brilliance—and high price—was more than he had expected. A bitter quarrel ensued; eventually, Leyland agreed to pay half of the two thousand guineas Whistler had asked for, and Whistler resumed work. His final touch was a mural depicting the artist and patron in the guise of two fighting peacocks and pointedly titled "Art and Money; or The Story of the Room." Whistler then left the room, never to see it again.

The "story of the room," however, continued to circulate, and in 1904, twelve years after Leyland's death, the room was put on the market, generating a flurry of publicity. Having purchased the *Princesse* in 1902,

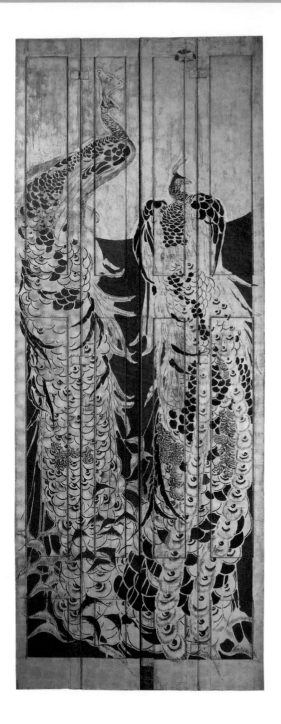

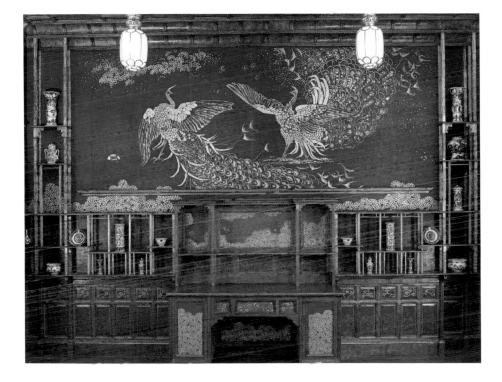

Freer likely saw the opportunity to acquire the Peacock Room as fortuitous. He reassembled the room in his Detroit home and, because he didn't care for porcelain, displayed iridescent East Asian, Islamic, and American ceramics on its shelves.

Following Freer's death in 1919, the Peacock Room was transported to Washington, D.C., and installed in the new Freer Gallery of Art. Located between the Chinese galleries and rooms devoted to Whistler, the Peacock Room, once again filled with Kangxi porcelain, functions as a link between the Asian and American collections, an embodiment of aesthetic correspondence between East and West. No longer primarily a story of "art and money," the Peacock Room is now a chapter in the history of art, which Whistler called "the story of the beautiful."

Early Evening
Winslow Homer (1836–1910)
1881/1907
Oil on canvas; 83.8 x 98.5 cm
Gift of Charles Lang Freer
Freer Gallery of Art, F1908.14

Winslow Homer began this painting in 1881 in Cullercoats, a fishing village on the northeast coast of England, and finished it after he returned to the United States in 1883 at his studio in Prout's Neck, Maine. Under the dual influences of the British landscape tradition and the rugged environment of Northumbria, Homer transformed his art to express a profound respect for the enduring forces of nature. Forming a monumental, self-contained unit, the two women of Early Evening seem oblivious to the approaching sea captain or the buffeting coastal winds.

An earlier version of Early Evening, titled Sailors Take Warning (Sunset), was exhibited at the 1893 World's Columbian Exposition, where it was described as a "large canvas representing three girls on a rocky shore." Some years later, in 1907, Homer cut down the canvas and altered the original composition. Scientific research conducted with radiography in 1992 revealed that he had painted out a third female figure and incorporated part of her skirt into the dress of the right-hand figure. He also altered aspects of the landscape to match the New England coast more closely, and he changed the color of the sky as well. In describing the evolution of the composition in a 1907 letter to his brother Charles, Homer noted, "I have made a new thing representing early evening—it is now a very fine picture." A year later Charles Lang Freer found the figures "so beautifully done" that he decided to add Early Evening to his collection where, he explained to the art dealer Roland Knoedler, "it is unfolding new beauties daily. I am glad to possess it."

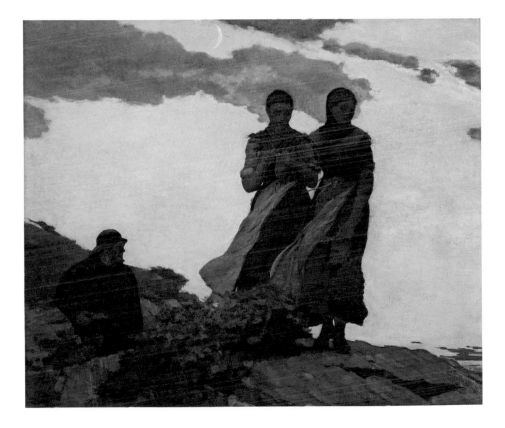

Dawn

Dwight William Tryon (1849–1925)
1893
Oil on canvas; 71 x 154.6 cm
Gift of Charles Lang Freer
Freer Gallery of Art, F1906.86

Winter

Dwight William Tryon (1849–1925)
1893
Oil on canvas; 71.5 x 155.2 cm
Gift of Charles Lang Freer
Freer Gallery of Art, F1893.17

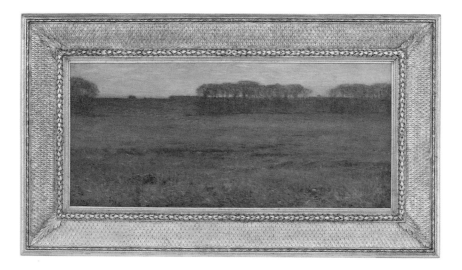

This pair of paintings, which originally hung on opposite sides of a double fireplace, was part of a series of seven landscapes that Dwight William Tryon painted for the reception hall of Charles Lang Freer's home in Detroit. Freer envisioned the house as a haven from business concerns, and Tryon collaborated with his patron, architect Wilson Eyre, and several other artists to achieve what Tryon called "perfect harmony" throughout. Working on a visually unified ensemble allowed the artist to extend color harmonies beyond his canvases and into the surrounding space. Within the private, controlled domain of Freer's home, art and life merged to become, as a friend of Freer's later recalled, "a dream of beauty, inside and out."

The splendid Stanford White frames surrounding *Winter* and *Dawn* echo the silver tonalities of the canvases. A close friend of Freer and Tryon, White believed the frame should enhance the overall composition of a painting and link it with its environment, and he produced many such designs for the American works in Freer's collection. Here, the leaf pattern on the frames is in keeping with the landscape theme, and the unusual silver-toned gilding would have harmonized with the pickled woodwork and silver-stained oak chairs that Freer had ordered for the hall. As Tryon recalled to his biographer, Henry C. White, "in a mysterious way, the pictures fitted and completed the whole thing."

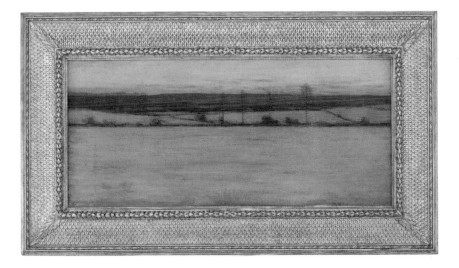

Harmony in Green and Rose: The Music Room

James McNeill Whistler (1834–1903)

1860–61

Oil on canvas; 96.3 x 71.7 cm

Gift of Charles Lang Freer

Freer Gallery Art, F1917.234

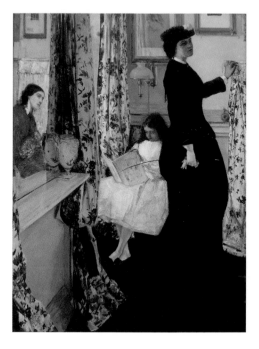

At first glance, this painting—described by Whistler's artist friend Henri Fantin-Latour as "le tableau avec l'amazone," the picture with the horsewoman—appears to be a straightforward examination of a Victorian interior. Begun shortly after Whistler moved from Paris to London, it depicts the music room in the home of Whistler's half-sister, Deborah Haden, whose reflection is in the mirror on the left. Deborah's daughter, Annie, is absorbed in a book while Isabella Boot, a family friend, appears in a black riding habit, a boldly painted, up-to-the-minute costume that presents a marked contrast to Deborah's conventional, faintly rendered gray gown.

Harmony in Green and Rose was not publicly exhibited until 1892, when Whistler praised the picture for its apparent simplicity: "Such *sunshine* …and such colour!" he declared in a letter to his wife. Yet the painting is actually more complicated. Thematic and compositional ambiguities subvert the simple realism of the depicted scene. The women, while literally close, are disengaged from one another, and the atmosphere of psychological distance is underscored by corresponding formal peculiarities: the perspectival grid formed by architectural and decorative elements in the room refuses to line up properly. The illusion of three-dimensional space is further undermined by the tilting floor and the strange angle of the image in the mirror. That the painting ultimately achieves visual coherence is due not to its narrative content or spatial structure but to the bold colors and patterned chintz draperies, whose repetition across the surface creates a sense of decorative unity.

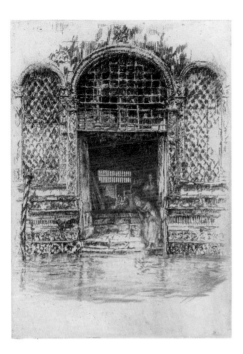

The Doorway

James McNeill Whistler (1834–1903)
1879–80
Etching and drypoint on paper; 29 x 20.2 cm
Gift of Charles Lang Freer
Freer Gallery of Art, F1898.385 (K188)

The Doorway is part of the First Venice Set, a group of twelve etchings by Whistler commissioned by the Fine Art Society, a London art gallery, in 1879. The palace depicted here dates to the early sixteenth century, but by the time Whistler saw it, it had become a furniture repair shop. Chairs dangle from the ceiling, and their legs are visible above the open doorway, echoing the grillwork on the façade and creating a delicate tension between patterned surface and illusionistic depth.

While in Venice, Whistler produced nearly fifty etchings, and a Second Venice set, comprising twenty-six images, became the first works by the artist purchased by Charles Lang Freer, who acquired the entire portfolio from a New York art dealer in 1887. Freer would go on to amass a near-perfect collection of Whistler's entire graphic oeuvre, including multiple states of individual images and many rare impressions.

Whistler achieved his earliest critical success as an etcher, but it was only during his time in Venice that he developed a truly experimental approach to the medium that enabled him to create aesthetic effects comparable to the painted Nocturnes of the 1870s. He used a feather to push the acid around the plate; once it was sufficiently bitten, he would ink the plate and pull the proofs himself, often returning to an etching years later to make adjustments and graphic changes. The subtle tonal variations that Whistler achieved in works like *The Doorway* resulted in evocative views that tend toward abstraction. These qualities, which enthralled Freer in 1887, had seemed almost incomprehensible to the British public a mere seven years earlier. When Whistler, badly in need of money, exhibited the First Venice Set at the Fine Arts Society in 1880, only eight sets sold, and critics dismissed the lot as "another crop of Mr. Whistler's little jokes."

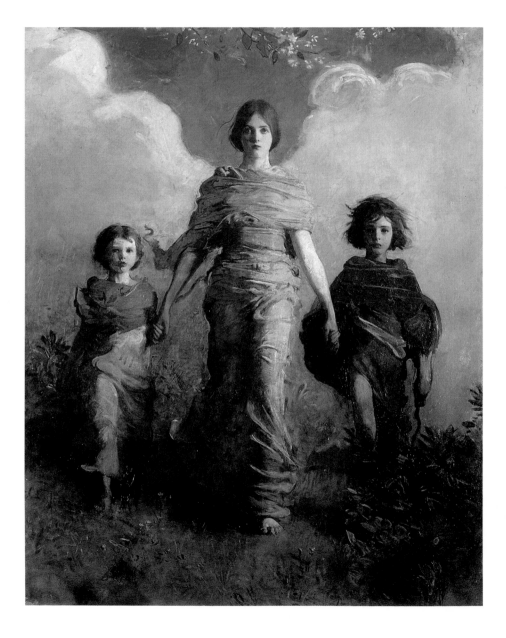

A Virgin

Abbott Handerson Thayer (1849–1921)
1892–93
Oil on canvas; 229.7 x 182.5 cm
Gift of Charles Lang Freer
Freer Gallery of Art, F1893.11

In 1893, the same year that Freer purchased *A Virgin* for the tremendous sum of $10,000, Abbott Handerson Thayer flattered his patron by comparing him to a Medici prince, whose generosity would enable the arts to "blossom and bear fruit." Thayer also indirectly linked himself to the great artists of the Quattrocento, and this painting, which originally hung in an open stairwell in Freer's home, is almost over-burdened by its art historical aspirations. The composition derives from Renaissance altarpieces, while the striding central figure—the eponymous Virgin—was inspired by the famous Winged Victory, the Nike of Samothrace, which Thayer had seen at the Louvre during his student years in Paris.

Leavening these weighty allusions, however, are more immediate, homely sources of inspiration, most notably Thayer's three children, who endured countless sessions posing for their father in the years following their mother's untimely death in 1891. The main figure is sixteen-year-old Mary, who had recently played the part of the Madonna in a local *tableau vivant*, while on either side are Gladys and Gerald, whom Mary had taken care of during their mother's illness. Thayer declared his children to be his "passion of passions." He explained to Freer, "I paint, during this period of my life, almost nothing but my children, yet must sell them. Perhaps these very paintings goad me to hurry to paint another and a better each time." At the time, Freer already owned a likeness of little Gerald and, shortly after shipping *A Virgin* to Detroit, Thayer sent his patron a complementary portrait of Mary, "a bonus," as he said, "to ease my conscience about the 10,000."

Like the Renaissance artists he emulated, Thayer depended more than most modern painters on individual patronage. Freer became his most steadfast supporter, and Thayer told him, "I would rather send every single picture…straight to your home than any other private house in this country."

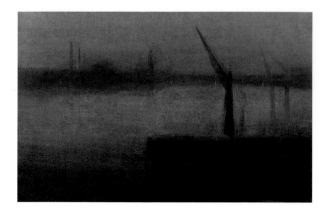

Nocturne: Blue and Silver—Battersea Reach

James McNeill Whistler
(1834–1903)
1870–75
Oil on canvas; 49.9 x 72.3 cm
Gift of Charles Lang Freer
Freer Gallery of Art, F1902.97a-b

After the American expatriate James McNeill Whistler moved from Paris to London in 1859, he always lived within sight of the Thames River and found it a constant source of inspiration for his art. Indeed, it was a luminous twilight view of the river in the summer of 1871 that led Whistler to produce some thirty-two paintings known as Nocturnes. These ephemeral images of urban darkness would become his most original contribution to nineteenth-century painting.

This work depicts the view toward Battersea that Whistler would have seen from his second-story residence in Chelsea. Battersea was an industrial area of London, full of factories, slag heaps, and smog, and Whistler's interest in the urban scene hints at his ties to the French realist movement earlier in his career. By the 1870s, however, Whistler had embraced and synthesized a new artistic influence and formal vocabulary: the flattened forms and asymmetrical compositional principles of Japanese prints. Here, he combined these elements—evident in the gracefully asymmetrical arrangement of masts, planar bands of color, and nearly monochromatic palette—with the evocative quality of moonlight to impart a poetic, mysterious beauty to the modern industrial scene. Although the work is not quite abstract, its ghostly forms and decorative composition push representational realism to the brink of dissolution.

Victorian viewers, accustomed to clearly rendered visual narratives, found the Nocturnes perplexing, but Charles Lang Freer appreciated what he described as their "refinement and mystery." He eagerly sought out eight examples and regarded this painting, which he purchased in 1902, as "one of the four greatest masterpieces of the Nocturnes."

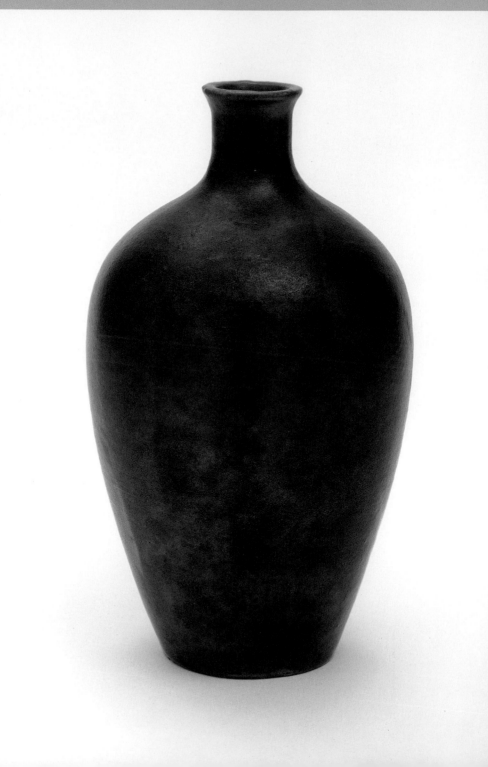

Pewabic bottle
Mary Chase Perry Stratton (1867–1961)
ca. 1917
Clay with iridescent glaze; 29.6 x 16.7 cm
Gift of Charles Lang Freer
Freer Gallery of Art, F1917.434

Charles Lang Freer was an early patron of the Pewabic Pottery, a ceramics workshop in Detroit founded by Mary Chase Perry Stratton at the turn of the twentieth century, and he acquired thirty-five pieces between 1908 and 1918. An avid collector of ceramics, Freer was keenly interested in aesthetic similarities between pottery glazes and the rich surfaces of the paintings he acquired. For her part, Stratton was inspired by the iridescent glazes of the antique Near Eastern ceramics in Freer's collection. In exchange for making his paintings available to Stratton for study, Freer challenged her to create a ruby red glaze. In 1909 she succeeded and went on to develop six iridescent hues for which Pewabic became famous. "And lovely—delicately, subtly lovely—it is," noted a reporter for the *Detroit Free Press* in 1909, "this fragile bit of pottery whose surface catches the light and reflects it in opalescent, shimmering tints that defy naming."

This red-violet bottle, with its metallic shimmer, is a fine example of the way Stratton experimented with glazing techniques by combining chemicals and colorants and by manipulating the atmosphere in the firing kiln. She applied a violet-green, copper-based iridescent glaze directly to the buff clay body of the bottle and fired it at an extremely high temperature, creating the opalescent surface that Freer so admired.

Stratton designed all of the pieces produced by Pewabic Pottery, but she left them to her assistants to throw on the potter's wheel. This freed Stratton to devote herself entirely to the art of glazing, which she called "painting with fire."

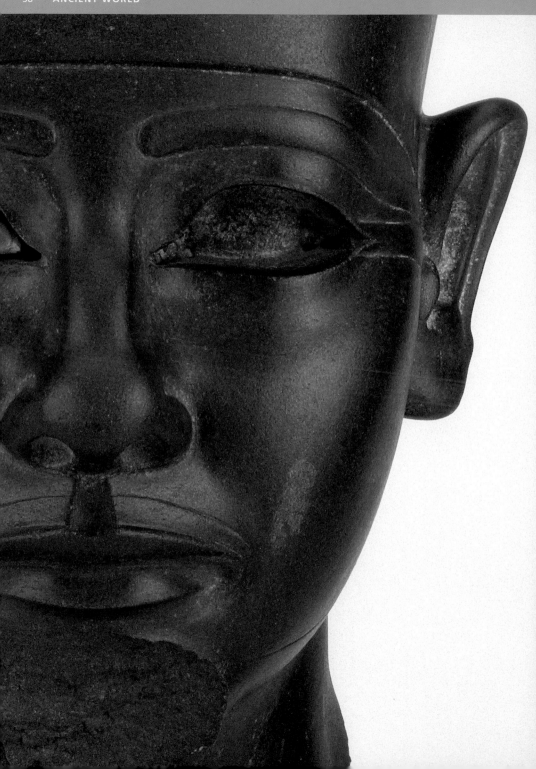

Head of a pharaoh

Egypt, Old Kingdom, Dynasty 5 or 6, ca. 2500–2170 BCE
Stone and copper; 58 x 17.7 x 26.8 cm
Freer Gallery of Art, F1938.11

This impressive head originally belonged to a full, most likely standing statue. The headgear and moustache identify the figure as an Egyptian pharaoh; the tall crown with rounded top, known as the White Crown, signifies his rule over Upper (southern) Egypt. The sculpture was originally painted, and the finely modeled features included eyes made of marl held in place by a copper rim. The full statue probably provided further clues to the figure's identity, perhaps through a hieroglyphic inscription that named him.

In ancient Egypt, such statues were placed in tombs to serve as eternal images of the deceased. Sculptors sought to convey the pharaoh's divine character through idealized representations, yet they also experimented with the naturalistic rendering of facial features, seen here in the modeling of the pharaoh's cheeks and lips. Details of the crown and face suggest this statue was carved in Dynasty 5 or 6, the period following the building of the Great Pyramids at Giza (circa 2500 BCE).

Jar

Egypt, New Kingdom, Dynasty 18, ca. 1539–1295 BCE
Glass; 9.4 x 6.2 x 5.6 cm
Gift of Charles Lang Freer
Freer Gallery of Art, F1909.421

Two-handled jar

Egypt, New Kingdom, Dynasty 18, ca. 1539–1295 BCE
Glass; 13.3 x 9.3 x 8.7 cm
Gift of Charles Lang Freer
Freer Gallery of Art, F1909.430

Flask

Egypt, New Kingdom, Dynasty 18, ca. 1539–1295 BCE
Glass; 8.4 x 6.7 x 3.8 cm
Gift of Charles Lang Freer
Freer Gallery of Art, F1909.416

These superbly crafted and beautifully preserved vessels are among the
world's premier objects of Egyptian glass produced during Dynasty 18
(1550–1307 BCE). Acquired by Charles Lang Freer during his second trip
to Egypt in 1906, the rich blues and blue-greens and lustrous surfaces he
found so appealing also were prized by ancient artisans, who sought to
imitate in glass the colors and appearance of favored gemstones, especially
turquoise and lapis lazuli. Created by winding threads of molten glass
around a core of sand, clay, and mud, the vessels served as containers for
costly perfumed ointments, scented oils, and cosmetics. Comparison with
similar objects excavated from royal glass workshops suggests that much
of the Freer glassware dates to the reigns of the pharaohs Amenhotep III
(1391–1353 BCE) and Amenhotep IV, who changed his name to Akhenaten
(1353–1335 BCE).

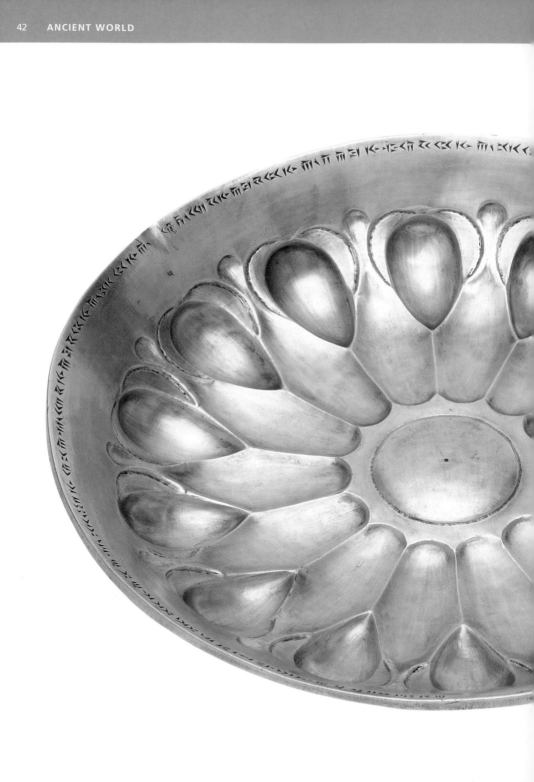

Phiale with inscription

Iran, Achaemenid period, 5th century BCE
Silver; 4.8 x 29.5 cm
Freer Gallery of Art, F1974.30

Written in Old Persian cuneiform, an inscription along the everted rim of this finely polished phiale (shallow bowl) states, "Artaxerxes, the great King, King of Kings, King of Countries, son of Xerxes, the King, of Xerxes [who was] son of Darius the King; in whose royal house this silver saucer was made." Clearly linked to the household of Artaxerxes I, the Achaemenid ruler of Iran (reigned 465–425 BCE), the phiale must have been part of the royal banqueting service, which comprised precious gold, silver, and glass vessels of different shapes and sizes. The ruler gave such pieces to noblemen, ambassadors, and other distinguished guests as a tangible expression of royal favor. According to some accounts, out-of-favor courtiers were denied the use of silver and gold tableware at the king's banquet table and could eat only from ceramic dishes.

This silver phiale was intended to hold wine, which played a central part in Achaemenid royal banquet etiquette. It was created by a combination of raising and sinking, while the inscription was probably "engraved" with a chisel or cutting tool into the silver surface. It is closely related to three other inscribed phiales and several plain ones, all of which are decorated with a distinctive design resembling a stylized blossom. Its fourteen petals radiate from a central omphalos, which would have allowed the wine to pool and create pleasing patterns.

Drinking horn

Iran, Parthian period, 1st century BCE
Silver and gilt; 23.5 x 12.4 x 30.4 cm
Gift of Arthur M. Sackler
Arthur M. Sackler Gallery, S1987.131

Drinking vessels created entirely or
partially in the shape of an animal had a
long history in ancient Iran and were
used to contain liquids consumed during
ritual or ceremonial occasions. This tall,
slender horn, which was made in several parts and
terminates in a zoomorphic protome (forepart) in the
shape of a ferocious lynx, exemplifies the artistic and
technical sophistication achieved in Iran during the
rule of the Parthians (247 BCE–224 CE).

 With its dramatic expression and unevenly
extended limbs, the lynx appears to be pouncing on an
imaginary prey, suggesting a tremendous sense of
movement and excitement. Selective gilding emphasizes
its form and further animates the lynx's tense body, which,
except for the added legs, was hammered out of a single
sheet of seamless thin metal—an astonishing technical feat.
A spout on its chest confirms its use as a vessel for pouring
wine and thus its association with Parthian ceremonial life.
Such objects, however, also were valued for their material
and weight, which in this case was inscribed in Parthian on
the turned-over rim.

Drinking horn

Iran or Afghanistan, Sasanian period, 4th century

Silver and gilt; 15.5 x 25.4 x 14.1 cm

Gift of Arthur M. Sackler

Arthur M. Sackler Gallery, S1987.33

This remarkable silver-gilt object is an extremely rare example of a drinking horn dating from the reign of the Sasanians in Iran (224–651), who controlled large areas of what is now west and central Asia from their homeland in southwestern Iran. While depictions of gazelles usually appear as quarry on Sasanian silver and gilt plates depicting royal hunts, here the head has been transformed into the protome (forepart) of an elegant drinking vessel. The head is part of the compact horn and furnished with a small and now-damaged tubular spout that barely protrudes from its mouth. The horn's middle section is decorated with a lion, a bull, and antelopes approaching a central tree. Such a scene likely had iconographic significance and embodied an important concept, that is, a special liquid, probably wine, was contained in and dispensed from the mouth of an animal that itself held powerful royal connotations.

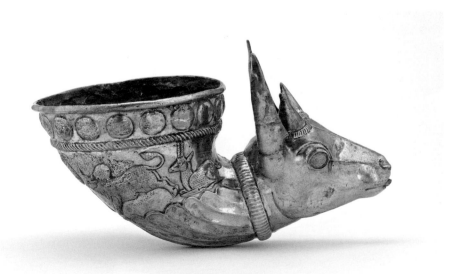

Inscribed ewers with female figures

Iran, Sasanian period, 6th–7th century
Silver and gilt; 35.5 x 16.9 x 14 cm (overall)
Gift of Arthur M. Sackler
Arthur M. Sackler Gallery, S1987.117, S1987.118

Pear-shaped vases, pouring vessels, and ewers in silver became popular in Iran during the latter part of the Sasanian dynasty (224–651). Closely related in form and elaborate gilded decoration, several are embellished with dancing female figures holding symbolic objects. The taller ewer is adorned with identical pairs of women; two wear diaphanous robes and play castanets while the others are dressed in heavily draped costumes and hold torches. On the second ewer, three scantly clad women hold pairs of different attributes: flower and bird, peacock and pyxis, child and fruit bowl. They wear wide tiara-like headbands, and the ends of their ribbons and robes fan out elegantly behind them.

The meaning of these female figures has inspired much discussion, leading to two alternative interpretations. One school of thought identifies the figures as Anahita, an Iranian goddess of abundance and fertility, with her priestesses. According to the other theory, the women were inspired by Roman personifications of the seasons and months as well as by female attendants in the cult of Dionysus, the Greek god of wine and ecstatic experience. The base of the taller ewer is inscribed "Khusraw, son of Babak," the name of one of its owners.

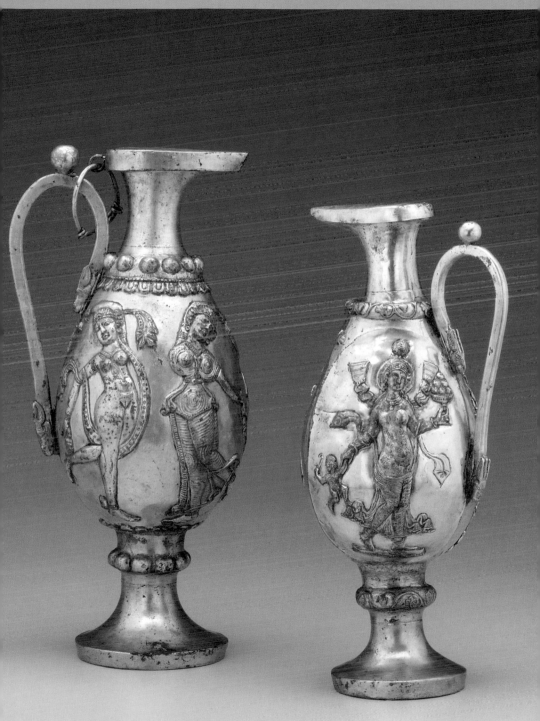

Beak-spouted jar

North Iran, Iron Age I–II, ca. 1350–800 BCE
Earthenware; 18.4 x 37.4 cm
Gift of Osborne and Gratia Hauge
Arthur M. Sackler Gallery, S1998.23

With its intriguing form, high technical quality, and smooth, polished
surface, this beak-spouted vessel epitomizes the monochromatic ceramic
tradition that flourished in ancient Iran during the Iron Age. Most of the
examples that survive today were found in tombs in north and northwestern
Iran. Potters in those areas often created remarkable vessels that evoked
in whimsical fashion the features of birds and other animals. Usually
handmade or slab-built, the vessels differed in form, size, and surface
treatment. Ranging in color from light gray to dark brown, they also are
characterized by highly burnished surfaces that give them a compacted,
lustrous appearance, recalling their metallic inspiration. The gray surface
of this perfectly preserved vessel imitates the color of tarnished silver,
while its elegant zoomorphic form is testimony to the superb skill of the
potters of ancient Iran.

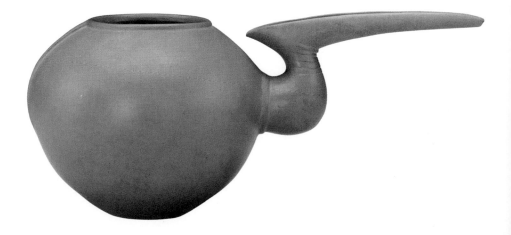

Plate

Iran, Sasanian period, 300–400
Silver and gilt; 24 cm (diam.)
Freer Gallery of Art, F1934.23

Among the earliest and most enduring representations of royalty created during the reign of the Sasanians of Iran (224–651) are images of a king on horseback hunting select quarry, such as a boar, lion, antelope, or gazelle. Such scenes, often embellished with gilding, were depicted on the interior of silver plates, about thirty of which have been found in Iran and neighboring countries. Produced in royal workshops, these plates were given as official gifts from the king to high-ranking individuals within or beyond the empire's frontiers. During the early centuries of Sasanian rule, silver production was controlled by a royal monopoly, and silver could be minted into coins or fashioned into objects only on the king's authority.

Although the plates are not labeled, individual Sasanian kings often can be identified by their crowns, which sometimes also appear on coin portraits. The figure on this plate generally is identified as King Shapur II (reigned 309–379), whose long rule was characterized by great military victories, especially in central Asia. Here, he hunts wild boars, a favorite royal pastime. This plate, one of the finest examples of its type, consists of several pieces that were made separately and then added to the main body.

The Four Gospels
(Codex Washingtonensis or Freer Gospels)
Egypt, 4th or 5th century
Ink on parchment; 20.8 x 14.3 cm
Gift of Charles Lang Freer
Freer Gallery of Art, F1906.274

During his first trip to Egypt in 1906, Charles Lang Freer was shown a series
of biblical manuscripts that he found of "exceeding interest." Claiming that
they "carried me completely off my feet," he soon acquired the works.
Known today as the "Washington Codex of the Four Gospels," the "Freer
Gospels," or "Codex Washingtonensis," they represent some of the Freer
Gallery's most historically significant holdings.

 This codex is the third-oldest manuscript of the gospels written on
parchment in the world. It originally comprised the text of the four canonical
gospels of the New Testament (Matthew, Mark, Luke, and John) but is now
missing some pages from Mark and John, and parts of John are later
additions. Written in Greek, the text was copied by a single scribe in a small,
legible, and sloping script with a pleasing consistency of style. As the scribe
devoted considerable attention to paragraphing, punctuating, and adding
diacritical marks, the volume probably was intended for public and liturgical
reading. Inconsistencies in the content, however, suggest the text was
compiled using different and fragmentary manuscript sources. The codex
also includes a statement that appears only in the Gospel of Mark.
Attributed to Jesus, it explains his role as Savior: "And for those who have
sinned I was delivered over to death so that they may return to the truth
and no longer sin, so that they may inherit the spiritual and incorruptible
glory of righteousness that is in heaven."

ΔΕΥΤΕΡΟΝΟΜΙΟΝ

ΑΥ

ΟΥΤΟΙΟΙΛΟΓΟΙΟΥϹ
ΕΛΑΛΗϹΕΝΜΩΥϹΗϹ
ΠΑΝΤΙΠΙͰΛ ΠΕΡΑΝ
ΤΟΥΙΟΡΔΑΝΟΥΕΝΤΗ
ΕΡΗΜΩΠΡΟϹΔΥϹΜΑϹ
ΠΛΗϹΙΟΝΤΗϹΕΡΥΘΡΑϹ
ΑΝΑΜΕϹΟΝΦΑΡΑΝ
ΚΑΙΓΟΦΟΛΚΑΙΛΟΒΟ
ΚΑΙΑΥΛΩΝ ΚΑΙΚΑΤΑ
ΧΡΥϹΕΑΕΝΔΕΚΑΗΜΕ
ΡΩΝΕΝΧΩΡΗΒΑΛΕϹ
ΕΠΟΡΟϹϹΗΕΙΡΕΩϹ
ΚΑΔΗϹΒΑΡΝΗ ΚΑΥ
ΕΓΕΝΗΘΗ ΕΝΤΩ
ΤΕϹϹΕΡΑΚΟϹΤΩΕΤΙ
ΕΝΤΩΕΝΔΕΚΑΤΩ
ΜΗΝΙΜΙΑΤΟΥΜΗΝΟϹ
ΕΛΑΛΗϹΕΝΜΩ
ΠΡΟϹΠΑΝΤΑϹ
ΙϹΛΚΑΤΑΠ
ΕΝΕΤΕΙΛΑΤΟΚΥ
ΤΟ
Ϲ
ΛΕΓ
ΕΝΤΗΓΗΜΩΑΒ ΗΡΞΑΤ
ΜΩϹΗϹΔΙΑϹΑΦΗϹΑΙ
ΤΟΝΝΟΜΟΝΤΟΥΤ
ΛΕΓΩΝ ΚϹΟΘϹΗΜ
ΕΛΑΛΗϹΕΝΗΜΙΝΕΝ
ΧΩΡΗΒΛΕΓΩΝ ΙΚΑ
ΝΟΥϹΘΩΥΜΙΝΚΑΤ
ΚΕΙΝΕΝΤΩΟΡΙΤΟΥ
ΤΩ ΕΠΙϹΤΡΑΦΗΤΕ
ΚΑΙΑΠΑΡΑΤΑΙΥΜΕΙϹ
ΚΑΙΕΙϹΠΟΡΕΥΕϹΘΑΙ
ΕΙϹΟΡΟϹΑΜΟΡΡΑΙΩ
ΚΑΙΠΡΟϹΠΑΝΤΑϹΤΟΥϹ
ΠΕΡΙΟΙΚΟΥϹΑΡΑΒΑΕΙϹ
ΟΡΟϹΚΑΙΠΕΔΙΟΝΚΑΙ
ΠΡΟϹΛΙΒΑΚΑΙΠΑΡΑΛΙΑ
ΓΗΝΧΑΝΑΝΑΙΩΝΚΑΙ
ΑΝΤΙΛΙΒΑΝΟΝΕΩϹ
ΤΟΥΜΕΓΑΛΟΥΠΟΤΑΜ
ΕΥΦΡΑΤΟΥ ΙΔΕΤΕ
ΠΑΡΑΔΕΔΩΚΑΕΝΩ
ΠΙΟΝΥΜΩΝΤΗΝΓΗ
ΠΟΡΕΥΘΕΝΤΕϹΚΛΗ
ΡΟΝΟΜΗϹΑΤΕΤΗΝΓΗ
ΗΝΩΜΟϹΑΤΟΙϹΠΑ
ΤΡΑϹΙΝΥΜΩΝΤΩΑΒΡ
ΚΑΙΤΩΙϹΑΑΚΚΑΙ
ΤΩΙΑΚΩΒΔΟΥΝΑΥΤΟΙϹ
ΤΟΙϹΚΑΙΤΩϹΠΕΡΜΑ
ΤΙΑΥΤΩΝΜΕΤΑΥΤΟΥϹ
ΚΑΙΕΙΠΟΝΠΡΟϹΥΜΑϹ

The Washington Codex of Deuteronomy and Joshua

Egypt, early 5th century

Ink on parchment; 30.6 x 25.8 cm

Gift of Charles Lang Freer

Freer Gallery of Art, F1906.272

Charles Lang Freer acquired this parchment codex in 1906 while he was visiting Cairo. Comprising one hundred and two leaves, the text is missing in some early sections, which probably contained the books of Genesis through Numbers. Divided into two columns, it is copied in an elegant script known as uncial (i.e., based on Roman capitals) on carefully ruled parchment. The beginnings of both Deuteronomy and Joshua are written in red ink, a practice called rubrication, which helped visually to underscore certain parts of a text. Rubrication became particularly common in European manuscripts after the seventh century.

After his purchase of these works, Freer devoted considerable time and resources to their research and publication. At a November 1912 exhibition at his house in Detroit, Freer displayed the Deuteronomy and Joshua manuscript in a special case in the celebrated Peacock Room, alongside his Japanese, Chinese, Iranian, Egyptian, and Korean ceramics.

Entry into Jerusalem

From *The Gospel according to the Four Evangelists*
Cilicia, Armenia, 2nd half of the 13th century
Ink, opaque watercolor, and gold on parchment; 33 x 24 cm
Freer Gallery of Art, F1932.18

One of eight Armenian manuscripts acquired by the Freer Gallery between
the 1930s and 1950s, this volume is among the finest and most profusely
illustrated texts from the Armenian kingdom of Cilicia, located along the
Mediterranean shores of southern Anatolia (in present-day Turkey). Although
unsigned and undated, the illustrations recall the style of the celebrated
thirteenth-century Armenian painter T'oros Roslin, the well-known master of
the Hromkla scriptorium, whose signed works date from 1256 to 1268.
Notable for his delicate palette, subtle and expressive figures, and innovative
iconography, Roslin transformed Armenian painting in the thirteenth century.

The artist's stylistic characteristics are evident in *Entry into Jerusalem*,
based on the Gospel of Matthew (21:8–11). In a radical departure from
earlier manuscript illustrations, Roslin has translated the narrative into the
language of everyday life. Jesus—accompanied by a great "multitude [who]
spread their garments on the way [while] others cut down branches from
the trees"—enters Jerusalem, represented here by a temple. Riding a tired
and hungry donkey, Jesus's sensitively rendered face and pose suggest
compassion and understanding, and the figures in the crowd have been
subtly individualized to present human emotions ranging from curiosity to
bewilderment to submission. The painting conveys not only the didactic
meaning of the Gospel but, perhaps more important, its human and
psychological dimension.

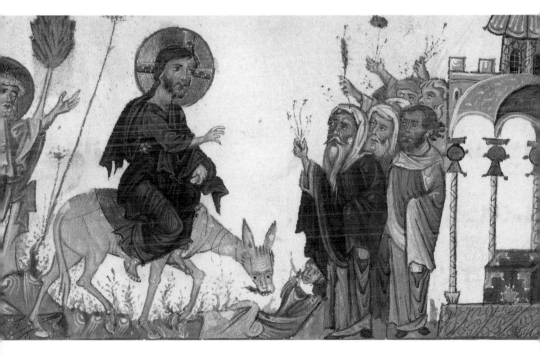

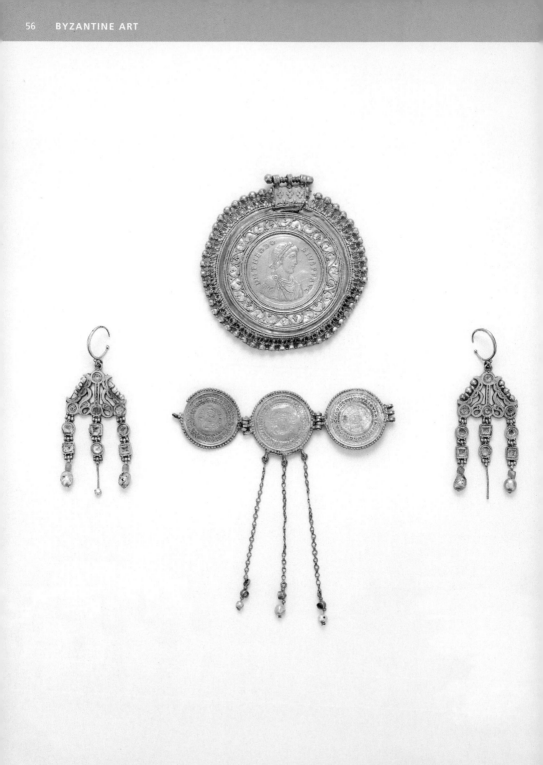

Pair of earrings

Turkey, 6th century
Gold; 10.6 x 4.4 cm
Gift of Charles Lang Freer, Freer Gallery of Art, F1909.64, F1909.65

Medallion consisting of a coin of Theodosius I

Byzantine, 6th century
Gold; 0.5 cm (diam.)
Gift of Charles Lang Freer, Freer Gallery of Art, F1909.67

Medallion consisting of three coins (*solidi*) of Justinian I

Byzantine, 6th century
Gold; 3.8 cm (diam.)
Gift of Charles Lang Freer, Freer Gallery of Art, F1909.68

In 1909, Charles Lang Freer purchased nine objects from a treasure cache
known as the Gold Treasure, originally consisting of some thirty-six pieces.
The Gold Treasure once was associated with either Upper Egypt or the city of
Antinoe on the east bank of the Nile, but recent scholarship has demonstrated
that the pieces are Byzantine in origin and date from the sixth century. They
may have been gifts by the emperor to loyal retainers in Egypt or brought
there by wealthy individuals from the heartland of the Byzantine Empire.

In addition to a pair of elegant pendant earrings, the group includes two
medallions. One consists of three interconnected coins of Justinian I (reigned
527–65), struck in Constantinople, the Byzantine capital. Each coin is set in
an elaborate gold frame with side loops for attachment, creating an impressive
ensemble. The central coin is further embellished with three chains that
terminate in small, irregular pearls, suggesting the three interconnected coins
probably served as a centerpiece of a larger ensemble, such as a girdle.
The second medallion comprises a single large gold coin, mounted into an
elaborately designed gold setting. On the obverse, the bust of Emperor
Theodosius I (reigned 379–95) appears in profile, while on the reverse he is
shown standing in military garb. The legend, which reads, "Restorer of the
State," is represented by a crowned, kneeling woman holding a cornucopia.
This impressive coin medallion was part of a gold pectoral and neck ring now
in the collection of the Metropolitan Museum of Art. Although Freer did not
continue to acquire Byzantine works of art, the quality of these works attest to
his discerning taste and concern for securing objects of the highest artistic and
technical standards.

Two disks (*bi*)

Northwest China, Qijia culture, Neolithic period, 2250–1900 BCE
Jade (nephrite); 42.5 x 1.9 cm (top, detail); 46 x 1.5 cm (bottom)
The Dr. Paul Singer Collection of Chinese Art of the Arthur M.
Sackler Gallery, Smithsonian Institution; a joint gift of the
Arthur M. Sackler Foundation, Paul Singer, the AMS
Foundation for the Arts, Sciences, and Humanities,
and the Children of Arthur M. Sackler
Arthur M. Sackler Gallery, S1999.120.2 (top, detail)
Freer Gallery of Art, F1956.16 (bottom)

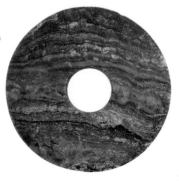

Jade was the first true luxury medium to emerge in ancient China.
Although the term is used to refer to a range of hard, beautifully figured
stones, most Chinese Neolithic and Bronze Age examples have been
scientifically identified as nephrite, geologically different from the
bright apple green jadeite used in much later times. Composed of
interlocked, fibrous crystals and occurring as pebbles and
boulders in a range of colors—due to iron, chromium,
manganese, or similar materials fused in the rock—nephrite is
an incredibly hard stone. It cannot be carved or even
scratched by metal but instead must be ground into shape
using quartz and other tougher minerals. These qualities and its
rarity inspired the ancient Chinese to value it very highly and
reserve its use for special purposes, such as jewelry and ceremonial
and ritual objects.

These two nephrite disks, among the largest known worldwide, share
a distinctive, stratified grain that suggests they were created from the same
jade boulder. Given their thinness and the gap between their diameters—
differing by 1½ inches (3.8 cm)—it is possible that the two slices were
separated by a third disk cut from the same stone. Around their perimeters,
both disks preserve parts of the dark brown weathered "skin" of their
source boulder, an indication that the craftsmen tried to make the objects
as large as possible. The two disks also possess conical holes, illustrating
that they were drilled from one side. All of these characteristics are
associated with the jade-working tradition of the late Neolithic Qijia culture
located in northwest China. Such disks may have been buried to protect or
honor the deceased, a practice first developed among earlier Stone Age
cultures in eastern China.

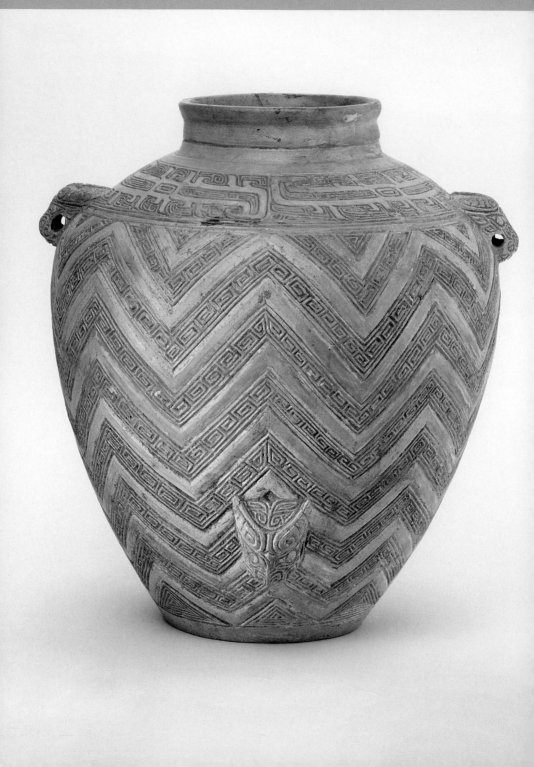

Jar

China, Henan province, Anyang
Shang dynasty, late 13th–early 12th century BCE
Unglazed white pottery; 33.3 x 30.3 x 28.3 cm
Freer Gallery of Art, F1939.42

Anyang, the capital of the late Shang dynasty between 1300 and 1050 BCE, is famed for its bronzes and jades, but this rare white ceramic jar represents another dimension of the artistic accomplishments of its craftspeople. At first glance, the jar resembles the form and decoration of cast bronze ritual vessels, but careful study has revealed a similar yet separate lineage of decoration. Shang white pottery has been found in such small quantities, all in the Anyang vicinity, that it may have been the product of a single specialized workshop. In startling contrast to the main developments of early Chinese ceramics—prehistoric painted earthenware, contemporaneous gray earthenware, and brown stoneware featuring the initial exploratory use of thin ash glaze—this small body of white wares is evidence of the discovery and use of pure white clay, kaolin. This rare material would be exploited once again by Chinese potters many hundreds of years later but fired to a sufficiently high temperature to turn it into porcelain. The Anyang potters had the raw material but not the kiln technology; thus, they fired their white "earthenware" at a lower temperature. Like its bronze counterparts, the soft and brittle ceramic ware was probably made for ceremonial and burial purposes. X-ray study by the Freer's conservation staff has revealed that this jar was shattered into twenty-four pieces, presumably while buried in a tomb; the pieces were recovered and reassembled. Traces of red iron oxide, probably employed in burial rituals, remain in the deep carving.

Pair of supports in the form of tigers

China, Shaanxi province, Baoji Xian
Middle Western Zhou dynasty, 900–850 BCE
Bronze; 25.1 x 15.9 x 75.1 cm (each)
Freer Gallery of Art, F1935.21, F1935.22

These two large animal-shaped bronzes with deep central cavities are unique objects, unmatched by anything excavated scientifically in China during the past eight decades. Extremely heavy, these undoubtedly authentic objects seem to have been made as supports for an unknown purpose, perhaps to raise a group of musical instruments or a special piece of furniture.

Whatever their intended function, they were obviously inspired by real tigers. Their low-slung bodies are elongated and possess powerful legs and a long, coiled tail. Their blocky, ferocious heads have erect ears and dots that represent whisker follicles. The flanks, lower legs, and tails are covered with stripes clearly meant to evoke the patterns on the live animal. On second look, however, the stiff forms are boxy and abstract, hovering between natural and decorative impulses. Signaling an early phase in Chinese representational sculpture, the three-dimensional images have been approached as an assemblage of flat views of sides, front, back, and top. The relief patterns marking the surface are also highly stylized, and the motifs used to distinguish the tigers' haunches from their flanks seem to have nothing to do with the animal world but instead resemble earlier mask motifs. In fact, these abstract, decorative motifs help suggest their date of manufacture since nothing else similar is known.

Tigers first appeared as sculpted or flat decorations on bronzes created in south China around the year 1400 BCE. While never as popular as dragons or birds, they soon appeared among northern bronzes and jades produced in the late Shang dynasty capital of Anyang (circa 1300–1050 BCE). As these Western Zhou and later examples illustrate, the subject remained popular throughout China for the duration of the Bronze Age.

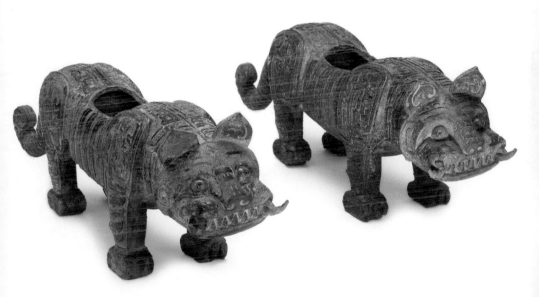

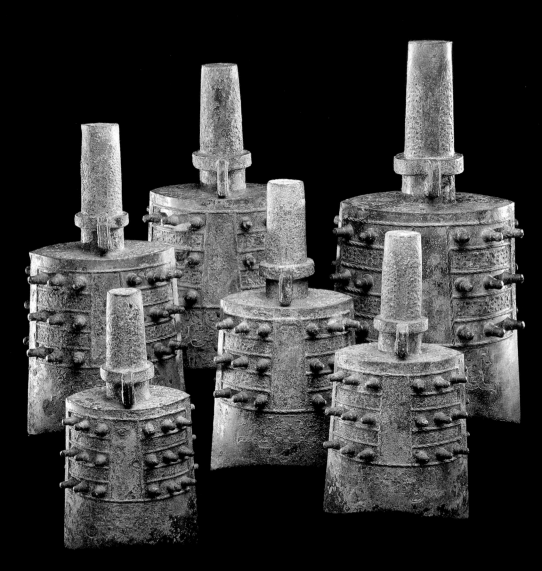

Graduated set of six *yong* bells

Southern or Southeast China
Early Eastern Zhou dynasty, late Spring and Autumn period,
late 6th or early 5th century BCE
Bronze; heights (smallest to largest): 25.4 cm, 29.0 cm, 31.1 cm, 35.5 cm,
39.0 cm, 44.0 cm
Gift of Dr. Arthur M. Sackler
Arthur M. Sackler Gallery, S1987.4–S1987.9

The scale, number, and variety of bronze bells preserved in Chinese burials suggest that music was important in ancient China. In the early Bronze Age (circa 1500–1050 BCE), bells ranged in size from small hand bells— graduated sets of three or more sometimes have been found in graves at Anyang—to much larger examples, the earliest of which have been discovered singly in non-tomb contexts in the provincial south. Over time, these two traditions merged to yield graduated sets of large bells, often found in aristocratic and royal tombs of the later Bronze Age (circa 1050– 206 BCE). These larger sets must have functioned both percussively and melodically in combination with other musical instruments, such as flutes and zithers made of bamboo, lacquered wood, and other more perishable media that have not survived into modern times.

The six bells in the Sackler collection are a mature reflection of this evolutionary sequence, one of the few such groups preserved outside China. Their composition and consistent design suggest they were made in a single pour from the same batch of molten bronze, a mixture of copper, tin, and lead. Each bell is similarly decorated by a tiered series of alternating bands of knobs and interlaced dragons above additional dragons in relief. These patterns can be found on other sets of bells excavated in southern China that are datable to the late sixth and early fifth century BCE.

Known in China as *yong* bells, sets like the Sackler group were cast with loops on their upper shanks that allowed them to be suspended by hooks from a now-lost sturdy stand, presumably made of wood. Their cavities are without clappers; they were designed, like earlier types of Chinese bells, to be played by being struck with mallets on their exterior. This would have allowed musicians to exploit the peculiar characteristic of bells with lens-shaped cross-sections. Depending on where they are struck, each bell can produce two different tones, attesting to the musical and casting accomplishments of ancient China.

Pair of plaques in the form of tigers

China, Henan province, probably Jincun
Late Eastern Zhou dynasty, Warring States period,
late 5th or early 4th century BCE
Jade (nephrite); 6.1 x 15.1 x 0.5 cm (left),
6.4 x 14.7 x 0.5 cm (right)
Freer Gallery of Art, F1932.43, F1932.44

According to sources at the scene, a severe rain storm in 1928 led to
flooding in the region of Luoyang. At one point, the ground in the suburb
of Jincun gave way, revealing a richly furnished tomb. With the absence of a
strong civil authority, locals "harvested" the grave, and the unearthed goods
quickly entered the international art market. Their extraordinary quality
ignited a search for similar tombs in the area, leading to the discovery of
eight large burials, now viewed as a royal cemetery for the late Zhou-dynasty
kings who ruled from Luoyang from 509 to 314 BCE. Findings included
extraordinary jades, grand sets of inscribed bronze bells, and beautifully cast
furnishings and vessels as well as chariot fittings, weapons, and personal
ornaments; many are inlaid with gold, silver, turquoise, lapis lazuli, malachite,
and glass. Undoubtedly produced in royal workshops, the objects reveal that
China's late Bronze Age was a period of significant artistic development.

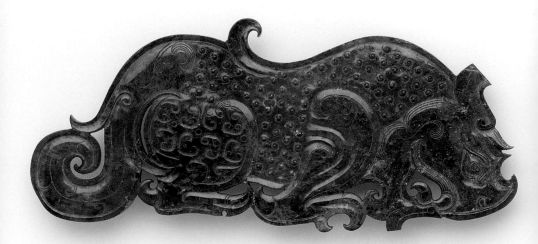

These nearly identical plaques usually are described as a pair of tigers. They also borrow elements such as a split, plume-like tail and feet with talons from other animals, evidence of a new creative approach to representing fantastic forms. Each beast possesses a lively, almost flickering silhouette with features defined partially in openwork. Facial details, formal contours, and the edges of the powerful shoulders and haunches are gracefully finished with bands in angled relief ornamented with elaborate patterns on both sides of each plaque. The bodies are textured by conical spirals that rise subtly above the surface; the legs are decorated with scrolling lines and curls, all highly polished. This kind of complexity, intricacy, and finish could be possible only with the use of fine metal tools and new working methods.

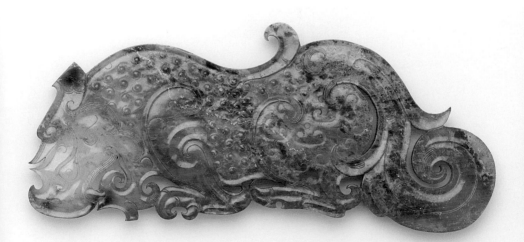

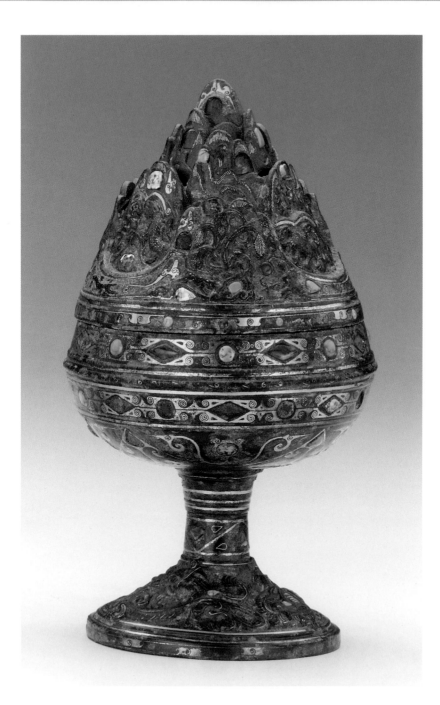

Incense burner in the form of a mountain (*Poshanlu*)

China, Henan or Hebei province
Western Han dynasty, ca. 2nd century BCE
Bronze inlaid with gold, silver, turquoise, and carnelian; 17.9 x 10 cm
Freer Gallery of Art, F1947.15a-b

Chinese people have used various fragrances to scent the air for at least
2,500 years. In ancient times, the burning of indigenous agarwood or
sandalwood developed as an aspect of traditional Chinese medicine. Even
today, Chinese herbalists continue to prescribe the treatment as a cure for
a number of different ailments. In the early imperial period, imported
incense, possibly including frankincense and myrrh, began to reach China
via the overland trade routes that linked East Asia with the Mediterranean
world. These imports later became associated with Buddhist devotion, as
incense was burned to purify and venerate the altar. Given the value, special
uses, and variety of forms of incense—powders, oils, and fabricated cones
and sticks— different kinds of containers were created for its use over time.

Exotic in every way, this luxurious burner was created shortly after
incense began reaching China from the West. Although its form relates
to Chinese notions of the Isle of the Immortals, said to be located in the
Eastern Sea, the use of precious metals (gold and silver) and inset colored
stones (turquoise and carnelian) are evidence of West Asian influences.
The burner takes the form of a jagged mountain peak raised on a short
pedestal whose supporting base includes a shallow basin for burning the
scented powders. When it was covered by its conical, perforated lid, smoke
from the smoldering contents emerged from holes hidden in the hills,
resembling clouds or mist rising from the mountain.

On the base, the metals and stones highlight aspects of the geometric
decoration. On the lid, they indicate swirling clouds as well as details of the
landscape and the figures it contains. Four different narrative scenes are
depicted in the mountains, including a hunter confronting a leopard at the
top of a hill. This is among the earliest depictions of a landscape in China,
a subject that would dominate the painting tradition of later centuries.

Western Paradise of the Buddha Amitabha

China, Hebei province, Handan
Southern Xiangtangshan Cave Chapels, Cave 2
Northern Qi dynasty, ca. 570
Limestone with traces of pigment; 158.9 x 334.5 cm
Freer Gallery of Art, F1921.2

This large stone relief is the earliest datable Chinese depiction of the
Western "Pure Land" (Paradise) of the Buddha Amitabha. Seated cross-
legged on a double lotus under a jeweled canopy at the center of the
symmetrical composition, the Buddha raises his right hand in a gesture of
reassurance. Near the bottom edge, two haloed bodhisattvas sit on either
side of a rectangular pool containing lotus
blossoms that bear reborn souls.
The rest of the scene is filled with
seated, standing, and floating
heavenly beings arranged to
suggest a space that recedes far
back into the distance, its scope
limited only by the two side towers
that illustrate the architectural beauty
of paradise.

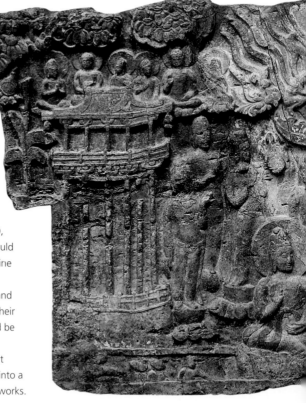

The heaven-focused subject
reflects new patterns of Buddhist
faith that emerged in China in the
sixth century. While earlier believers
based their spiritual efforts on the model
life of the historical Buddha (Shakyamuni),
Pure Land Buddhists believed salvation could
come through the direct assistance of divine
beings, such as Amitabha and his two
bodhisattvas, Avalokiteshvara (Guanyin) and
Mahasthamaprapta (Dashizhi). Through their
divine intervention, cycles of rebirth could be
broken by entry into Paradise, which was
available to all. In a way, this development
marked the transformation of Buddhism into a
religion of faith rather than simply good works.

This relief was created as an element of a Buddhist chapel hollowed out of a mountain at a place called Xiangtangshan, whose cave chapels were inspired by earlier Indian and central Asian prototypes. In its original setting, this scene appeared inside the cave, above the entrance, which appropriately faced west, the location of Amitabha's Paradise. Other sculptures in the Freer collection—a large relief showing a heavenly gathering of Buddhas and bodhisattvas (F1921.1) and a life-sized, freestanding bodhisattva (F1968.45)—probably came from the same cave.

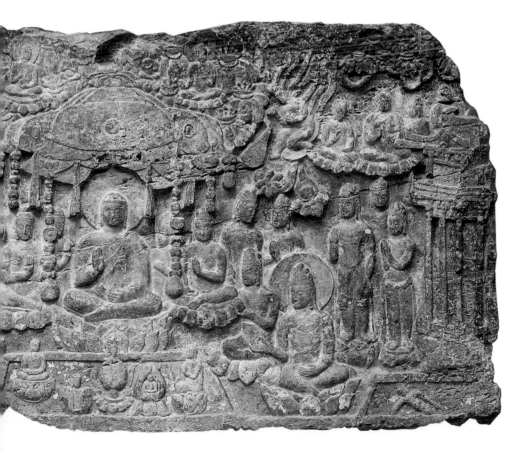

Figure of a seated woman holding a bird

China, Tang dynasty, first half of 8th century
Earthenware with *sancai* (three-color) lead-silicate glaze; 40.6 x 17.9 x 15.6 cm
Purchase–Friends of the Freer and Sackler Galleries,
Freer Gallery of Art, F2001.8

In China during the Tang dynasty (617–907), ceramic figures representing
supernatural guardians and humans ranging from "exotic" foreigners
to court figures to humble servants were buried with the elite. Made for
the tomb of an aristocratic individual, this engaging and graceful figure
represents the pinnacle of that tradition and opens a window onto Tang
culture. Her handsome face is topped by an elaborate double topknot; she
wears popular Central Asian-inspired clothing, including a short jacket sewn
of tie-dyed fabric; and she proudly displays "cloud-tipped" shoes. She seems
to commune with a pet, perhaps a parakeet or other imported bird.
Collecting "exotic" imported objects, particularly brightly colored birds, was
a sign of status in Tang China.

In the early seventh century, most burial figures were straight, slender
forms that seem almost two-dimensional in visual impact. A major change
occurred in the eighth century as potters began to inflect their work with
striking originality and sensitive observation. Through astute choices of
attributes and idiosyncratic actions, they imbued tomb figures with an
unprecedented degree of naturalism and individualism, despite the fact they
were still working on variations of a type. This figure was produced in a
mold and then touched up with freehand modeling. It is made of fine white
clay containing kaolin, a chief ingredient in porcelain, and the result creates
a soft white complexion like those of freshly powdered Tang women.

The manufacture of pottery figures embellished with multicolored lead-
silicate (*sancai*) glazes formed a specialized branch of the potter's craft in
northern China between 700 and 750. In the eighth century, funerals were
elaborate and, to some degree, competitive displays of wealth and status.
Tomb figures were placed on carts and transported through the streets in
grand processions. At least in theory, the number and size of the figures
were determined by rank. After the funerary parade arrived at the grave
site, the ceramics were lined up outside the tomb in a dazzling arrangement
and then interred with the deceased. Hundreds of ceramics were included
in a single burial. Large numbers of *sancai* wares have been found in tombs
of the elite in the areas around modern-day Xi'an and Luoyang.

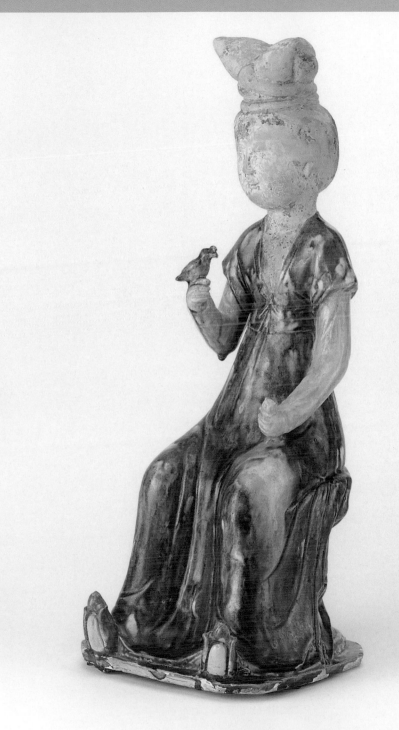

Mallet-shaped vase

Guan ware
China, Zhejiang province, Hangzhou
Southern Song dynasty, 12th century
Stoneware with Guan-type glaze; 23.2 x 14.1 cm
Gift of Charles Lang Freer
Freer Gallery of Art, F1911.338

The simple shape and nearly plain surface of this vase—made in the modest shape of a utilitarian wooden mallet used to pound fibers into paper or to soften woven silk—are the perfect foils for a glaze of complex color and texture. This glaze, termed *guan* ("official"), may be seen as a culmination of a long tradition of using glaze on high-fired ceramics, the potential of which was first recognized in China during the Shang dynasty (circa 1500–1050 BCE). Guan ware was produced, under close supervision of the Southern Song court, in two small workshops located within the capital city of Hangzhou. Typical of guan ware, the body of this vase was made of clay darkened with iron and shaved to extreme thinness. The glaze then was applied in several layers, ultimately becoming thicker than the clay body. The crackling that was carefully cultivated by the glaze formulation and firing process was stained selectively with iron pigment, clearly marking the direction of the potter's wheel, which spun clockwise.

Given the unsurpassed value of guan ware today, it is surprising to learn that in 1911 Charles Lang Freer bought this vase from a dealer in China for only $25 but paid $1,100 in Japan for a black-glazed Chinese tea bowl of a similar date.

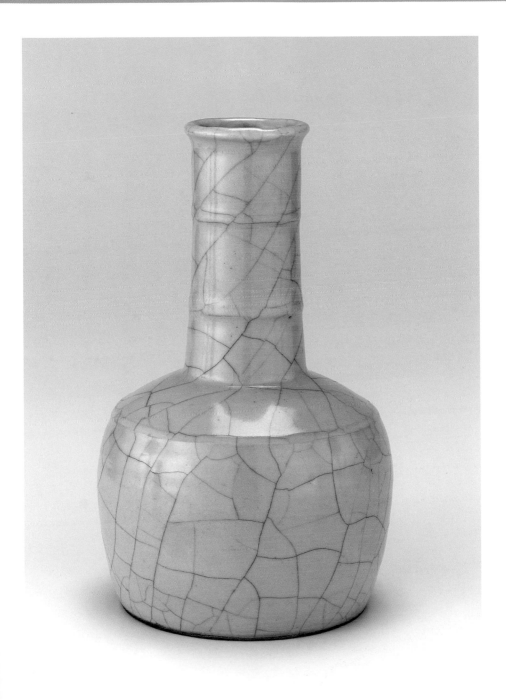

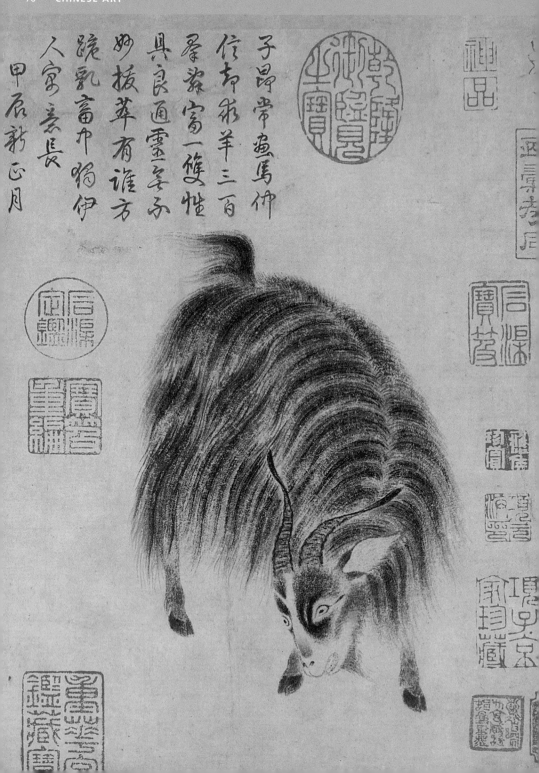

Sheep and Goat

Zhao Mengfu (1254–1322)

China, Yuan dynasty, ca. 1300

Handscroll, ink on paper; 25.2 x 48.7 cm

Freer Gallery of Art, F1931.4

A descendant of the imperial Southern Song dynasty (1127–1279), Zhao Mengfu lived through the Mongol rule during the Yuan dynasty (1279–1368) and was offered a position at the Mongol court. He was a preeminent literati painter and calligrapher of the early Yuan period whose rise to the top is indicated by his lofty title, Hanlin Academician Recipient of Edicts. One of China's most versatile and subtle artists, Zhao was an enthusiastic advocate of synthesizing the spirit of the ancient masters into one's own work. Although he was skilled in various subject matters—including figures, landscapes, birds and flowers, bamboo and rocks, and horses—this was his first attempt to depict a sheep or goat, which he did only when requested to do so.

> I have painted horses but have never painted sheep [or goat]. Because Zhongxin requested a painting, I playfully sketched these from life. Though I cannot match the ancient masters, somehow I have captured animal's essential spirit.

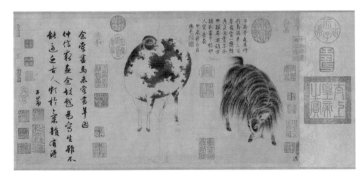

The polarizing quality of Zhao's calligraphic brushwork—dark versus light, dry versus wet—gives the unique subjects vivid visual contrast. The Freer Gallery's Sheep and Goat is the only one by Zhao recorded and in existence to date. It was treasured by collectors and connoisseurs of later dynasties, especially the Manchu emperor Qianlong (reigned 1736–96; see page 83), who personally added the outside label, frontispiece, inscription, and also fourteen seal impressions—not only expressing his personal views on the work but also asserting his absolute ownership of it.

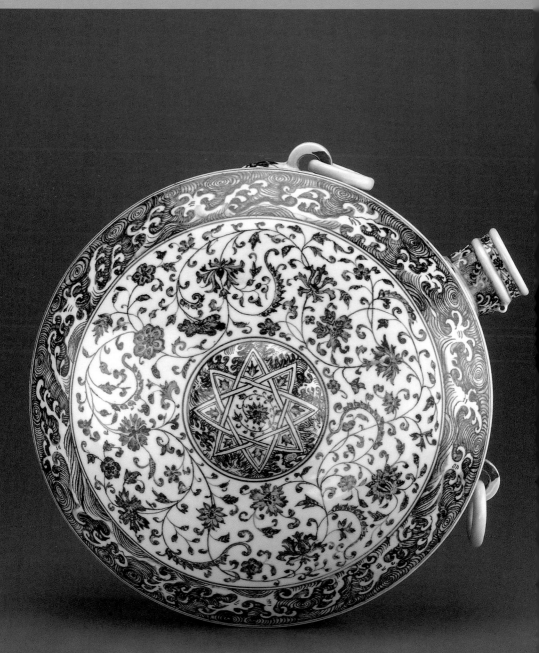

Flask

China, Jiangxi province, Jingdezhen
Ming dynasty, early 15th century
Porcelain with cobalt pigment under colorless glaze;
46.9 x 41.8 x 21.3 cm
Freer Gallery of Art, F1958.2

The large flat expanses and sharp angles natural to a metal shape are difficult to translate into porcelain clay, which, when so forced, tends to warp and crack during firing. This porcelain canteen was produced in successful defiance of such technical difficulties. It is one of a group of blue-and-white ceramics that appear to have been made for a Chinese clientele fascinated by Islamic metalware. The hybrid decoration combines an Islamic eight-pointed star on the central boss; waves, a common Chinese motif; and Chinese floral scrolls on wiry stems that seem to reflect awareness of Islamic decorative motifs. Mimicking the deep socket on the back of its single extant West Asian brass counterpart, also in the Freer collection (see page 134), the back of this canteen bears a shallow circular indentation.

 The canteen's spout once had a domed stopper as well, but it is unlikely that this porcelain vessel, far heavier than the metal version, was ever used. It may have been intended purely as an ornamental object for a patron particularly interested in Islamic shapes and decoration.

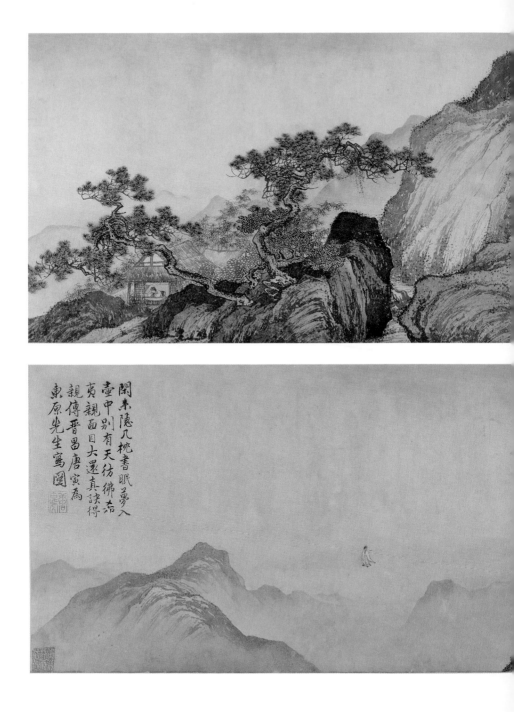

閑來隱几枕書眠夢入
壺中別有天彷彿若
英親面目大還真訣得
親傳晉昌唐寅為
東原先生寫圖

The Thatched Hut of Dreaming of an Immortal

Tang Yin (1470–1523)
China, Ming dynasty, early 16th century
Handscroll, ink and color on paper; 28.3 x 103 cm
Freer Gallery of Art, F1939.60

Among the most talented and colorful painters in China during the Ming dynasty, Tang Yin was born in the city of Suzhou, located on the Grand Canal between Lake Tai and the Yangzi River, where the arts flourished along with commerce. Although he came from the merchant class, the young Tang Yin was introduced to Suzhou's gentry and literati, and he took first place in the provincial examination in Nanjing in 1498 at the age of nineteen (eighteen by Western reckoning). The following year, he traveled north to Beijing to take the metropolitan examination, which should have launched his civil service career. His involvement in a scandal, however, left him no choice but to return to Suzhou, where he resumed his old familiar life of drinking and socializing. To earn a living, Tang took up his paintbrush and became very successful. In fact, his work was so popular that to meet the art market's demand, his teacher, Zhou Chen, who was about twenty years older, served as a ghost painter for his young protégé.

The Thatched Hut of Dreaming of an Immortal caused heated scholarly debates during the 1960s about who was the artist: teacher or pupil. Today, however, most scholars attribute the painting to Tang Yin. It is dedicated to his childhood friend Wang Dongyuan, who, as the story unfolds (top), can be seen through the window of the thatched hut under the pine trees, falling asleep on a pile of books and dreaming of an immortal, the Daoist Xiyi. The left of the painting features a tiny immortal flying over the distant mountains (bottom) and Tang's inscription:

> Leisurely leaning against the desk, I napped on books.
> Dreamily entering a gourd filled with wine, I found another world.
> Seemingly it was the Daoist Xiyi, I saw in person.
> Personally the secret of Dahuan elixir of life, I then received.

The Qianlong Emperor as Manjushri, the Bodhisattva of Wisdom

Imperial workshop, with face by Giuseppe Castiglione
(Lang Shining, 1688–1766)
China, Qing dynasty, mid-18th century
Unmounted *thangka*, ink and color on silk; 113.6 x 64.3 cm
Purchase–Anonymous donor and museum funds
Freer Gallery of Art, F2000.4

> Wise Manjushri, king of the dharma, lord who manifests as the leader of men.
> May your feet remain firmly on the Vajra Throne.
> May you have the good fortune that your wishes are spontaneously achieved.

Written in a slender gold script on the dais, the Tibetan inscription indicates that this work is a depiction of Manjushri, the bodhisattva (enlightened being) of wisdom. The facial features also identify the subject as Emperor Qianlong (reigned 1736–96). The Tibetan Buddhist concept of an emperor as a reincarnated Manjushri originated during the Yuan dynasty (1271–1368) when China was under Mongol rule. This extraordinary *thangka*, a traditional Tibetan-style religious painting, reflects not only Qianlong's pious personal beliefs in Tibetan Buddhism but also his political strategy of using religion to stabilize neighboring Tibet and the Mongol tribes. Here, the emperor is surrounded by one hundred eight deities (an auspicious number in Buddhism), subtly claiming his rule over both the religious and secular worlds. This Buddhist hierarchy was especially important to the Tibetans and Mongols within Qianlong's Manchu empire.

The superimposed image of Qianlong, particularly the exquisite modeling of his facial features, has long been believed to be the result of European influence from the Italian Jesuit painter Giuseppe Castiglione, who resided at the Chinese imperial court. However, recent scholarship, resulting from research in the imperial archives, suggests a Tibetan *thangka* that reflects both European influence and Chinese blue-and-green landscapes could not have been produced earlier than 1771, five years after Castiglione passed away. The earliest realistic portrait in a *thangka* actually was done circa 1771 to 1780 by Ignatius Sickeltart (1708–1780), a Bohemian Jesuit painter who collaborated with Giuseppe Castiglione on several monumental painting projects for the court. It is possible that Sickeltart painted this portrait of Qianlong.

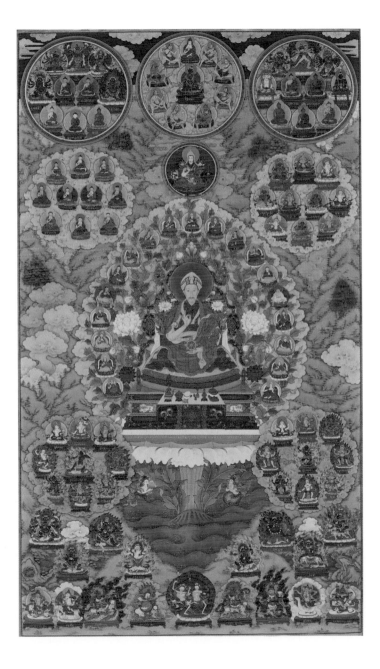

Untitled

Jananne al-Ani (Iraq, b. 1966)
1996
Color photographic prints from black-and-white internegatives;
133.4 x 200.6 x 2 cm (each, with frame)
Arthur M. Sackler Gallery, S1998.112.1, S1998.112.2

Born in Iraq to an Irish mother and an Iraqi father, Jananne al-Ani relocated
to Britain at an early age. After graduating from the Byam Shaw School of
Art in London, she received her master of arts in photography at the Royal
College of Art in 1997. Much of her early work examines the role of
photography in the representation of women and the visual construction
of the "Orient" for Western audiences.

For this pair of photographs, al-Ani was inspired by late nineteenth-
and early twentieth-century studio portraits of the exotic "Oriental"
woman. Here, she arranged her mother, three sisters, and herself according
to age and in progressive stages of veiling. In the image on the right, al-Ani
appears second from the right with her face revealed. By reversing the order

on the left, only her eyes are visible. Moving back and forth across the figures, from a mother to her youngest daughter, between the concealed and the entirely unveiled, this work questions the power of photography not simply to represent but also to create its subjects. Supposedly distinct categories—such as East and West, past and present—are complicated further by the denim shorts and other fragments of contemporary clothing that emerge from the shadows. By including herself and members of her family in this composition, al Ani adds a personal dimension to her exploration of constantly changing individual and social histories.

Installed facing each other, the two large-scale prints challenge the relationship between the observer and the observed. Standing between the photographs, the viewer is trapped in the midst of the women's direct, starkly framed gazes. In a reversal of the earlier Orientalist portraits, this group of women and their veiled doubles elude the possibility of visual capture and easy comprehension.

Monkeys Grasp for the Moon

Xu Bing (China, b. 1955)
2001
One of two; lacquer on Baltic birch wood;
2591.1 x 78 x 4.1 cm (overall)
Arthur M. Sackler Gallery, S2004.2.1-.21

Xu Bing developed his drawing and woodcut techniques by printing posters and newsletters during China's Cultural Revolution and through formal training in printmaking at the Central Academy of Fine Arts in Beijing. His controversial and iconic work *Book from the Sky* (1987) brought Xu both widespread recognition as a prominent figure of the New Wave art movement and also harsh criticism from the Chinese government. In 1990, he relocated to the United States, where, confronted with an unfamiliar context, he continued to explore his fascination with the aesthetics of language and to question its relationship to ways of thinking and communicating ideas. Xu's innovative installations and performances earned him a prestigious MacArthur Fellowship in 1999.

For his first major exhibition in the United States, presented at the Arthur M. Sackler Gallery in 2001, Xu created *Monkeys Grasp for the Moon* as a site-specific installation; it was permanently installed in the museum's pavilion in 2004. Composed of the word "monkey" in twenty-one languages, including Chinese, Arabic, English, and Braille, the segments resemble monkeys whose arms and tails link together to form a long line stretching from the skylight above to the pool below. With his distinctive approach to seeing language as form, Xu reinterprets a well-known Chinese folktale about monkeys who try to touch the moon, only to discover that it is a vanishing reflection on the water. Designed for the main staircase of the Sackler Gallery, *Monkeys Grasp for the Moon* playfully comments on notions of communication and interaction across cultures, traditions, and artistic styles.

Landscape in Scroll

Roy Lichtenstein (United States, 1923–1997)
1996
Oil and magna on canvas; 263.5 x 125.7 cm
Partial and promised gift of Dorothy Lichtenstein
Arthur M. Sackler Gallery, S2001.31

A major figure in the American pop art movement of the 1960s, Roy Lichtenstein created iconic works that celebrated the bold, direct compositions of mass-produced images, such as those found in advertising or comic books. Developing a distinctive style drawn from mechanical print processes, he vigorously reinterpreted, even subverted, painterly expression through the use of strong black outlines, primary colors, and the illustrator's technique of constructing images with Benday dots.

Following an exhibition in 1994 of landscape paintings by French artist Edgar Degas (1834–1917), Lichtenstein increasingly turned to earlier non-Western painting traditions. Just as Degas found inspiration in Japanese prints for his treatment of color, space, and mood, Lichtenstein examined the way Chinese landscape painters portrayed majestic mountains and misty views. Part of a series of paintings titled Landscapes in the Chinese Style, Landscape in Scroll transforms the monumental landscape composition developed during the Northern Song dynasty (960–1127) and the romantic atmosphere of the Southern Song dynasty (1227–79). Through his signature technique, Lichtenstein distilled the familiar mountain imagery into blue dots of varying intensity on a white background and set the entire scene in a hanging scroll format with a bold graphic border. By reinterpreting Chinese painting, Lichtenstein simultaneously evoked both the lyrical treatment of nature found in a classical art tradition and a modern conceptual approach to image production.

Untitled (Grandfather)

From the series *Updating a Family Album*
Malekeh Nayini (Iran, b. 1955)
1997
Computer-generated photograph; 42 x 29.6 cm
Arthur M. Sackler Gallery, S2000.122

Digital technology allows Malekeh Nayini to travel through time and reestablish a link to her past. Born in Iran, she studied photography and cinematography in the United States and France before the 1979 Iranian revolution. Uprooted from her country and family surroundings, Nayini turned to her computer and the photographic medium to create highly personal, often whimsical works.

Based on a portrait of her grandfather taken in the style of the *carte de visite*, a popular format for photographs during the mid-nineteenth century, this image is part of a series titled *Updating a Family Album*. Seated at a table and staring solemnly into the camera, he is surrounded by a set of curious props, such as a parrot, a bowl on the draped table, and a painting on the wall, that are reminiscent of elements used in traditional Iranian painted portraiture to indicate social rank and sophistication. While this carefully arranged scene, with its hints of sepia and stylized border, resembles European-inspired photographic portraits, Nayini's inclusion of the contemporary stamp design and the portrait of Imam Ali in the background recasts her subject in a new cultural context.

By manipulating her family album, Nayini transports her subjects to a different time and reinvents her personal history. Using vivid colors and patterns both to enliven her compositions and accentuate their artificiality, she calls attention to the nature of the photographic image, particularly the portrait, as a visual and cultural concept whose meaning is subject to continuous reinterpretation.

Who Am We?

Do-ho Suh (Korea, b. 1962)
2000
Four-color offset prints on paper; 91.4 x 61 cm
Arthur M. Sackler Gallery, S2006.34.3.1-.25

Conceived as an installation that covers entire walls of an exhibition space, Who Am We? is a photo reproduction composed of faces from the artist's high school yearbooks. Cropped as identical spheres, then neatly arranged in rows, the portraits become a uniform pattern that dissolves into neutral tones when seen from a distance. Approaching the walls, the viewer discovers thousands of individual faces staring back, each one revealing subtle differences in hair, facial features, and expressions. Depending on proximity and perspective, the viewer is drawn into an experience that oscillates between the physical sensation of space through pattern and color and the dramatic psychological effect of encountering a boundless sea of human faces. Through scale and repetition, Suh visually conveys tension between individual identity and the overwhelming power and anonymity of the larger social collective.

Much of Suh's work incorporates autobiographical subject matter and architecture as a way of expressing personal observations drawn from his experiences of living in two cultures. After completing graduate studies in traditional painting at Seoul National University, he relocated to the United States and earned additional degrees in painting and sculpture at the Rhode Island School of Design and Yale University. Suh continues to work both in the United States and Seoul. Through his keen observations of different cultural approaches to human and spatial relations, his works often provoke thought on the dualities inherent in contemporary, mobile life.

Boden Sea / Utwill

Hiroshi Sugimoto (b. Japan, 1948)
1993
Gelatin silver print on paper; 42.4 x 54.3 cm
Arthur M. Sackler Gallery, S1994.7

Hiroshi Sugimoto was born in Japan in 1948 and has lived and worked in
the United States since the 1970s. His ongoing series Seascapes, begun
in 1980, depicts sites throughout the world, yet regardless of where a
photograph was taken—Germany's Boden Sea, the Black Sea from the
shores of Turkey, or the Yellow Sea from Cheju Island in South Korea—the
composition and point of view remain constant. In Sugimoto's mesmerizing
views of water and sky, the long exposure time allows for an almost
palpable sense of surface movement and atmosphere. These aesthetic,
rather than topographical, images verge on abstraction. Sea and sky are
bisected into equivalent bands of gray. Shifting gradations document the
tonal range of black-and-white photography as well as the physical quality
of natural light. Reiterating these compositional devices from image to
image not only eliminates distracting details of place but also heightens
perceptions as they unfold over time. Within these limits of time, space,
and structure, Sugimoto conveys infinite, if subtle, differences in tone and
atmosphere. For all their initial tranquility, the surfaces of these seascapes
seem to hum and vibrate upon prolonged viewing. The cumulative effect
is similar to gazing at the sea itself.

Kumbh Mela, Allahabad, Uttar Pradesh

Raghubir Singh (India, 1942–1999)
1977; printed 2003
Digital photographic print; 80 x 120 cm
Gift of the Estate of Raghubir Singh
Arthur M. Sackler Gallery, S2003.2.33

In his exploration of the color, light, and sense of time inherent in the medium of photography, Raghubir Singh consistently turned to India for inspiration. Born in Rajasthan in 1942, he moved to Paris in the 1970s but continued to travel throughout the South Asian subcontinent. Internationally acclaimed and widely published, his works typically were recognized as extraordinary images of India. By the 1980s, however, he began to receive critical attention as a pioneer in the history of art photography for using color film at a time when black-and-white images were the norm. For Singh, capturing colors was fundamental to representing the daily life and spirit of a particular place and context. Influenced by French photographer Henri Cartier-Bresson (1908–2004), he also sought that "decisive moment" and often included unusual details that removed images from the realm of the timeless into a specific record of the photographer's presence and sensibility.

In his last photographic series, A Way into India, Singh honored the Ambassador, or "Amby," the car that took him from Kashmir to Tamil Nadu and many points in between during his thirty-year career. Introduced by Hindustan Motors in 1957, the Amby was a familiar member of Indian life for half a century, serving as official limousine, taxi, or family car. Reminiscent of the 1950s British Morris sedan but built domestically, its distinctive silhouette became an icon of India in the post-independence era. In Singh's images, the ubiquitous Amby not only serves as a subject but also offers its windows and mirrors as a frame for perceiving the photographer's world. At a Hindu festival in Uttar Pradesh, it waits patiently while a tent canopy teeters in the background.

Photograph © Succession Raghubir Singh

Four scenes from the life of the Buddha

Pakistan or Afghanistan, ancient Gandhara, Kushan dynasty,
late 2nd–3rd century CE
Schist; 67 x 289.8 x 9.8 cm
Freer Gallery of Art, F1949.9

Buddhism originated with the teachings of the historical Buddha
(Enlightened One) in the fifth century BCE. The Buddha was born into
a royal family in Lumbini (present-day Nepal) but as a young man he
renounced his kingdom to seek a means to end human suffering.
After years of meditation, he came to realize that permanence is illusory,
attachment leads to misery, and wisdom offers liberation from the endless
cycle of rebirth (*samsara*). According to tradition, the Buddha taught in
northern India until the age of eighty, when he abandoned his body and
entered the blissful state of nirvana.

Carved in a dark crystalline stone with glinting flecks, these panels
depict four great events in the life of the Buddha. They represent his
miraculous birth from his mother's side; his enlightenment beneath the
bodhi tree (*ficus religiosa*); his first sermon at Deer Park in Sarnath; and his
release from the cycle of rebirth (*parinirvana*). Artists presented the climactic
moment in each event by focusing on a large central image of the Buddha
or his mother. The superbly balanced and finely carved reliefs were created
during the Kushan dynasty in Gandhara (present-day Pakistan and
Afghanistan) when the region was a cosmopolitan crossroads with ties to
India, western Asia, and the classical world. Gandharan artists synthesized
visual and cultural elements from each of these cultural regions to create
what are perhaps the earliest figural images of the Buddha. In these panels,
for example, the Buddha wears a toga-like robe and has a wavy topknot
adapted from Greco-Roman images of Apollo.

The panels once adorned a monumental stupa (dome-shaped
reliquary) that contained the relics of the Buddha or other great teachers.
Buddhist monks and nuns as well as lay devotees viewed the life events
of the Buddha in chronological order as they walked clockwise around
the mound, keeping their more auspicious right sides aligned to the
enshrined relics at the stupa's core.

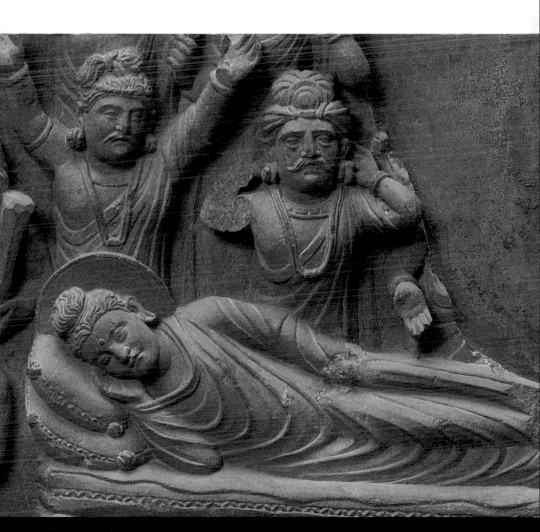

The Freer Parvati
Queen Sembiyan Mahadevi as the Goddess Parvati

India, state of Tamil Nadu, Chola dynasty, ca. 990
Bronze; 107.3 x 33.4 x 25.7 cm
Freer Gallery of Art, F1929.84

During the tenth century, sculptors in South India refined the art of bronze casting to create elegant images of Hindu deities that were carried in procession within and outside the precincts of temples. The posture, lotus-holding gesture, and jewels of this superb bronze are characteristic of the goddess Parvati (also known as Uma), the wife of the great god Shiva. However, her sloping shoulders, which differ markedly from the straight shoulders specified for deities in iconographic manuals (*shilpa shastra*), suggest a human subject.

The bronze's supple naturalism, its evocation of soft flesh, and its elongated proportions indicate that it was created during the reign of Queen Sembiyan Mahadevi (died 1006). Widowed in 957 when she was still a young woman, the devout queen was an ardent patron of Hindu temples across the Chola territory. Her son commissioned a portrait sculpture of his mother, which was draped in silks and paraded through the town called Sembiyan Mahadevi each year on her birthday. This graceful image, which represents a woman deified as a Hindu goddess, may very well be that bronze.

The bronze epitomizes the Indian figural aesthetic, which seeks to convey the essential nature of the body rather than reproduce its outward physiognomy. The master sculptor created a willowy form that organically swells from the ground like a flower. Each element of the queen's figure corresponds to ideals of beauty that circulated widely in court literature and devotional poetry, such as arms like pliant bamboo shoots, a neck that bears the three rings of a conch shell, and a nose curved like a parrot's beak. By representing Sembiyan Mahadevi's body as a compilation of poetic metaphors, the sculptor expressed her essential qualities as a devout and beneficent queen.

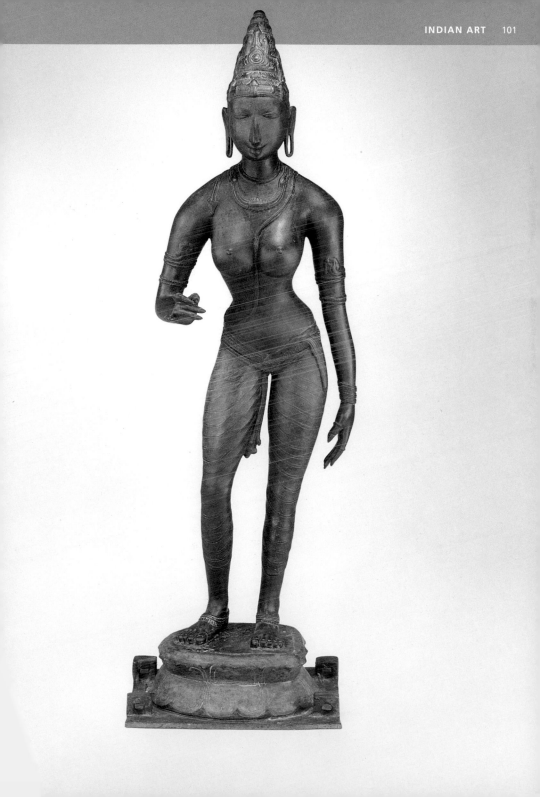

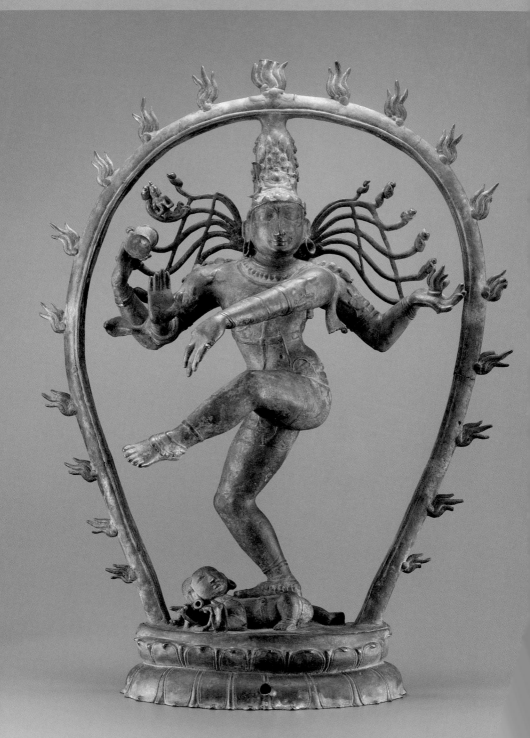

Shiva as Nataraja, Lord of the Dance

India, state of Tamil Nadu, Chola dynasty, ca. 990
Bronze; 70.8 x 53.3 x 24.6 cm
Purchase—Margaret and George Haldeman and Museum funds
Freer Gallery of Art, F2003.2

From the sixth to the ninth centuries, Hindu poet-saints in southern India
sang of the cosmic powers and multiple forms of the great deity Shiva.
To convey the profound vision of Shiva dancing the universe into existence,
one saint wrote:

> He dances, a whirl
> of motion,
> the great lord
> bearing fire, crowned
> with the crescent and with Ganga,
> as his golden anklets chime
> and his serpents dance, too.
> (*Translated by Vidya Dehejia*)

By the end of the tenth century, Shiva as Lord of the Dance (Nataraja) had
become the dynastic emblem of the Chola rulers, whose empire extended
over much of southern India. This bronze Nataraja reveals how Chola dynasty
sculptors transformed the saints' eloquent verses and profound beliefs into
an exquisitely realized form. Shiva Nataraja gracefully dances the world into
existence as he holds aloft the cosmic flames of its cyclic destruction. The
god stands lightly upon the body of the dwarf of ignorance, who raises his
head to look up adoringly at Shiva. Lifting his left foot high across his body,
Shiva extends his left arm to offer refuge to devotees. His upper hands hold
the drum that beats the world into existence and the flame that signifies its
inevitable destruction. Goddess Ganga (the sacred river Ganges), her lower
half depicted as flowing water, is positioned in Shiva's matted locks, which
unfurl like ribbons from the movements of the dance. The flaming, oval
aureole (*prabha*) expands the graceful energy motion outward and upward.

While stone images of Nataraja were created before the tenth century,
the technical mastery and artistic genius of Chola bronze casters perfected
this form, which remains the Nataraja archetype to this day.

Throne Leg

India, state of Orissa, Ganga dynasty, 13th century CE
Ivory; 35 x 15.6 x 13.1 cm
Gift of Charles Lang Freer
Freer Gallery of Art, F1907.8

Since at least the second century CE, Indian sculptors have
carved thrones of ivory that proclaimed royal command. This
ivory throne leg from eastern India exhibits bold
imagination and technical dexterity. Its artist
exploited the natural curve of an elephant tusk
to convey the thrusting power of a *gajasimha*, a
mythical creature combining the strength of
both elephant (*gaja*) and lion (*simha*).
Symbolizing both the might and dispassion of a
great king, the *gajasimha* forcefully grips a
demonic warrior in his sharp claws. The broad
smooth surfaces of the elephant-lion create a
powerful contrast to the intricately realized
mountain landscape. Archers and wildlife
gambol over the diminutive mountain's crags
and caves, while a hermit meditates and a lion
slumbers. The two-dimensional swirls of the
lion's mane, mountain peaks, and demon's hair
provide rhythmic counterpoints to the sensitively
observed animals that swell with breath and twist
in space.

Between the eighth and thirteenth centuries,
the Eastern Ganga dynasty reigned over Orissa, a state
on the eastern coast of the Indian subcontinent.
Like many medieval kingdoms, it sought to expand its
territories and wealth by bringing peripheral tribal regions
under royal command. With his wild hair and small, round
shield, the warrior dangling from the *gajasimha's* trunk
may represent one of the tribesmen that the Orissan
kings sought to dominate.

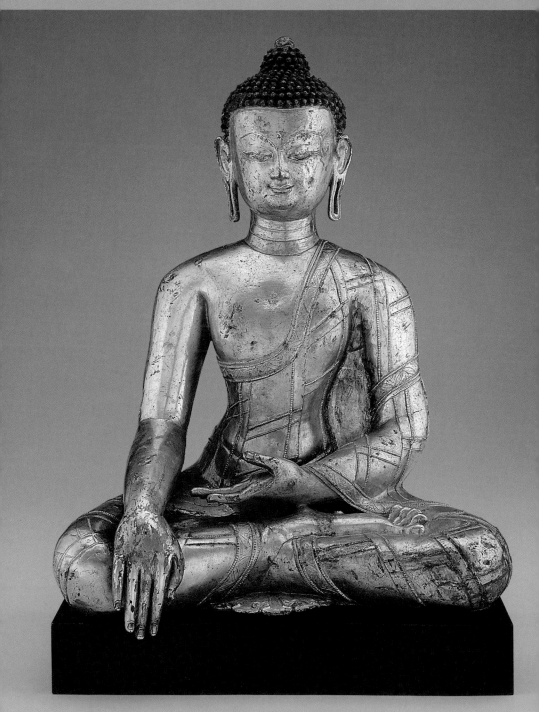

Seated Buddha

Central Tibet, 14th century
Gilt-copper with pigment; 45 x 34 x 27 cm
Purchase—Friends of Asian Arts
in honor of the 10th Anniversary of the Arthur M. Sackler Gallery
Arthur M. Sackler Gallery, S1997.28

This serenely radiant Buddha was created to grace the altar of a Buddhist monastery in central Tibet. Like most Tibetan Buddhist sculptures, it was hollow-cast so that it could contain relics, prayers, and mantras (sacred syllables) that increased its spiritual potency.

For Tibetan Buddhists, a consecrated image of the Buddha is both a symbolic representation of ultimate truth and its very presence. By viewing the sublime proportions, colors, and characteristic attributes of the Buddha, worshipers perceive their own potential for enlightenment. The Buddha's superhuman perfection, which he attained over many lifetimes of selfless deeds, is indicated by his cranial bump (*ushnisha*), a symbol of transcendental wisdom, and the forehead dot (*urna*) that signifies renunciation. The gold that adorns the sculpture invokes his purity and perfection. Other iconographic elements refer more specifically to the events of his last lifetime on earth, when he was born as Prince Siddhartha, achieved omniscience, and taught the Buddhist path to disciples. His earlobes, now empty but elongated from wearing heavy royal ornaments as a youth, and his patched robe signify his renunciation, while his hand reaching downward refers to the moment when he called upon the earth goddess to witness his enlightenment.

Buddhism first traveled from India to mountainous, snow-covered Tibet in the seventh century. Over the subsequent centuries, India remained a revered source for canonical texts and aesthetic ideals.

Here, the sensuously modeled torso and sensitive hands invoke sculptures made in northeastern India from the ninth to the eleventh centuries. In contrast, the broad face, marked stylization of the hair, and knoblike *ushnisha* are Tibetan. Although the entire sculpture was gilded and polished, the face and hair were further colored. The "cold gold" applied to the Buddha's face gleams with a skin-like softness when lit by altar lamps; his hair is blue to indicate its dark beauty.

Four Mandala Vajravali Thangka

Central Tibet, Ngor Monastery (Shakya Order), ca. 1430
Opaque watercolor and gold on cloth; 87.7 x 78 cm
Freer Gallery of Art, F1997.22

In the Vajrayana Buddhism practiced in Tibet, *thangkas* (paintings on cloth) are supports for ritual, meditation, and visualization. This luminous *thangka* represents four realms, or mandalas, of the Buddhist deities Varahi and Humkara. Each intricately detailed mandala is comprised of the geometric forms of square and circle and employs a limited but glowing palette of red, blue, yellow, and white against a black background. During meditation, Buddhist adepts (initiated practitioners) first encounter the cremation grounds surrounding the mandalas, where jackals consume corpses amid delicately drawn skeletal remains. They then enter the mandala through one of four gateways flanked by arched entranceways and cross its outer realms. Finally, they concentrate their meditative practice on the transcendent awareness of the deity at the center of each mandala. At each stage, the practitioner achieves spiritual wisdom by visualizing and internalizing a deity's qualities.

The *thangka* invites us to consider the religious and cultural connections that joined India, Tibet, and Nepal in the fourteenth century. India, the birthplace of Buddhism, remained an authoritative source of learning for Tibetans and this rare four-mandala *thangka* is based on an Indian Buddhist text, the *Vajravali*. Portraits of two abbots at the *thangka*'s center reveal that its patron was associated with the Ngor monastery of Tibet's Sakyapa tradition. Its style—and Ngor tradition—indicate that its painters came from Nepal.

In creating *thangka*s, artists sought to achieve both iconographic accuracy and glowing beauty. They created a smooth working surface by treating cotton with a mixture of kaolin and hide glue, which was then stretched, dried, and polished on a wooden frame. Their pigments were largely local. Blue and green were derived from mineral rocks near the capital of Lhasa, most reds and yellows came from ochre earths, black was the soot of pine wood, indigo and lac (for red) came from India, and powdered gold was obtained from Nepali merchants. The best painters skillfully balanced the proportions of chalk, which gave opacity to the pigments, with those of the glue that served as a binder and determined sparkle and luminosity.

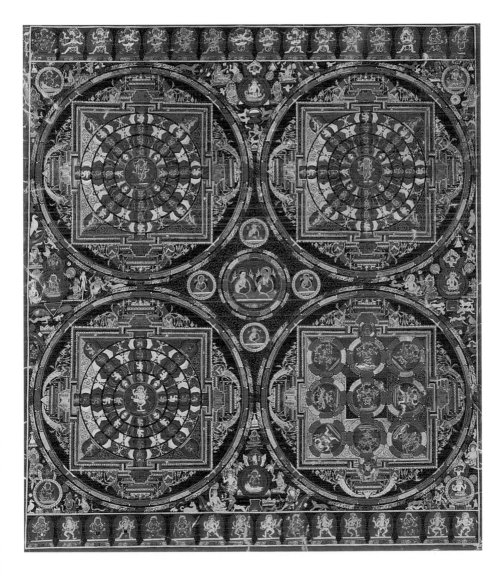

Hanuman Returning with the Mountain of Healing Herbs

From the Freer *Ramayana* (The Story of Rama)

Zayn al-'Abidin

India, Mughal dynasty, late 16th century

Ink and opaque watercolor on paper, modern bindings; 27.8 x 18 cm

Gift of Charles Lang Freer

Freer Gallery of Art, F1907.271.236a

This exuberant image depicts the Hindu monkey-god Hanuman flying over the Indian subcontinent. Grinning wildly, Hanuman appears to leap across the pale blue page as he triumphantly carries an entire mountain's peak. The folio's painter, Zayn al-'Abidin, conveyed both Hanuman's muscular strength and his extraordinary flight with élan. Curling and looping branches of fantastic trees and curative plants spring from the lavender mountain, while diminutive animals frolic in the landscape below.

The folio is one of one hundred thirty full-page paintings in the Freer *Ramayana*, an illustrated Persian translation of a great Hindu epic. The *Ramayana*, which entered written form as early as the fourth century BCE, exists in countless retellings. Akbar (reigned 1556–1626), the third ruler of the Mughal empire (1556–1857), had it translated into Persian, the language of his court, in the late sixteenth century. The emperor subsequently permitted his general, Abd al-Rahim, to produce a personal copy. Both the emperor and the high-ranking nobleman were Muslims who shared an abiding interest in India's diverse religious and cultural traditions. Abd al-Rahim, who was proficient in Persian, Turki, and Hindi, had a passion for reading, which he indulged even during his bath. He established a major library, which was said to have welcomed a hundred visitors a day, as well as an atelier for the production of manuscripts that employed at least ninety-five artisans, calligraphers, and painters.

In 1907, Charles Lang Freer purchased this *Ramayana* from a retired British army colonel, believing that it was produced in Akbar's imperial atelier. When Freer Gallery of Art curator Richard Ettinghausen translated the colophon in 1969 and identified its patron as Abd al-Rahim, the manuscript achieved a level of scholarly importance that Charles Freer could not have anticipated. Recognized as a keystone in tracing the transmission of imperial aesthetics to regional workshops across northern India, it became known as the Freer *Ramayana*.

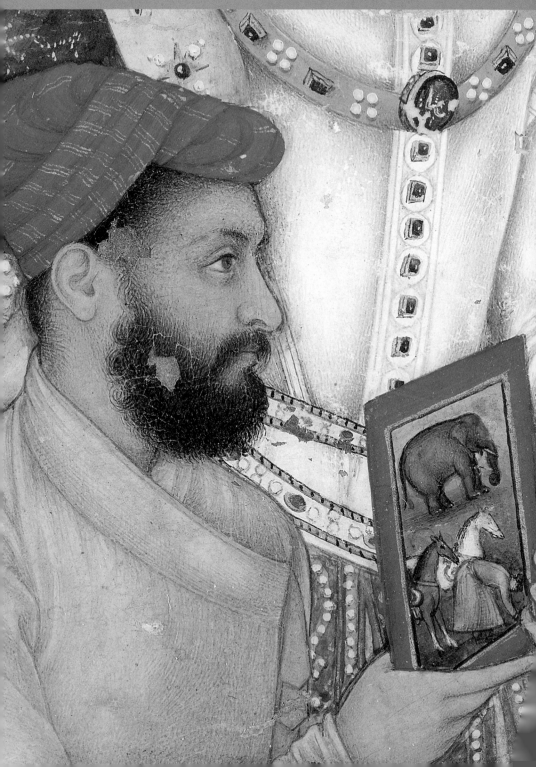

Jahangir Preferring a Sufi Shaykh to Kings

From the St. Petersburg Album
Painting by Bichitr; India, Mughal dynasty, ca. 1620
Borders by Muhammad Sadiqi; Iran
Opaque watercolor, ink, and gold on paper;
25.3 x 18.1 cm
Freer Gallery of Art, F1942.15a

An unparalleled school of painting emerged under the Mughal emperors, who came to power in north India in 1526. Emperor Jahangir (reigned 1605-27) encouraged his artists to create lustrous images of historical events, persons, and luxury objects with astonishing fidelity and refinement of technique. Artists such as Bichitr turned these same skills to allegorical images, endowing statements of imperial desire with the authority of real events. Drawing from life, Bichitr captured the aging emperor's soft jowls and paunch belly with unflinching honesty. In typical Mughal fashion, he also adapted motifs from the artworks and luxury objects collected by—or given as diplomatic gifts to—the globally connected court. Here, cherubic angels based upon European sources animatedly inscribe "O Shah, may the span of your life be a thousand years" in Persian on the fantastic hourglass throne.

A broad allegorical meaning is encapsulated in the Persian inscription written in the cartouches above and below the scene, which states that the emperor turns to religious men for guidance even as kings stand waiting before him. The white-bearded shaykh receiving the imperial gift of a book was in charge of the Sufi shrine at Ajmer, where Jahangir lived from 1613 to 1616. The shaykh's presence in the painting is a celebration of a sacred source of Mughal dynastic power. Bichitr drew upon a painting by Johannes de Critz to create the portrait of King James I of England, which he positioned between a generalized image of an Ottoman sultan and his own self-portrait holding a small, red-bordered painting.

Artisans within Jahangir's atelier originally placed the painting within a delicately painted border that was bound into an album for the emperor's delectation. When Nadir Shah of Iran sacked Delhi in 1739, the painting was brought to Iran and remounted within the bright floral borders seen here.

Humayun Seated in a Landscape
From the Late Shah Jahan Album
Payag (act. 1590–1650)
India, Mughal dynasty, ca. 1650
Opaque watercolor and gold on paper; 37 x 25.4 cm
Purchase—Smithsonian Unrestricted Trust Funds, Smithsonian Collections
Acquisition Program, and Dr. Arthur M. Sackler
Arthur M. Sackler Gallery, S1986.400

The Mughal emperor Shah Jahan (reigned 1627–50) expressed both imperial grandeur and his love of jewel-like perfection in commissions as monumental as the Taj Mahal or as small as this luminous album folio. The painting represents Shah Jahan's great-grandfather, Humayun, contemplating a jeweled turban ornament (sarpech), an emblem of royal power and wealth.

 The tranquil setting of this painting retrospectively casts the stability of Shah Jahan's empire onto the earlier emperor's reign (1530–40 and 1555–56), for Humayun's life was anything but serene. Unable to fend for the kingdom that he had inherited from his father, Humayun was forced into exile in 1540 by his enemies. After fifteen years of hardship, he regained power and was able to preserve the Mughal empire. The plane tree next to Humayun may be an allegorical reference to the emperor's triumph over his misfortunes because it flourishes even though its main trunk has been severed.

One of the most renowned artists in Shah Jahan's atelier, Payag consciously combined two painting styles in this work. The high horizon, golden sky, and three-quarter portrait are directly appropriated from Iranian painting and thus express Mughal pride in their ancestry from Timur, whose dynasty ruled eastern Iran for more than a century (circa 1381–1506). In contrast, Humayun's softly draped robe and the atmospherically rendered grassy landscape in the foreground epitomize the Mughal interest in the real appearance of the world and, more specifically, Payag's adroit mastery of naturalism.

Payag's painting is set into painted borders that further underscore imperial authority. The youth in the center on the left is dressed in Indian garb and holds a parasol, a symbol of honor that appears above images of the Buddha in early Indian art. The two older figures wearing Iranian court attire offer gold coins and a cloth-covered sword, the very means that allowed Humayun to reconquer India in 1555.

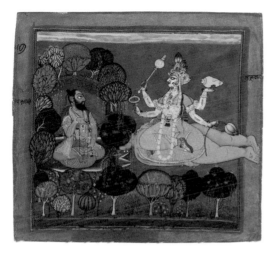

The Goddess Bhadrakali Worshiped by the Sage Chyavana

From a Tantric Devi series
India, Pahari Hills, ca. 1660–70
Opaque watercolor and gold on paper;
21.3 x 23.1 cm
Freer Gallery of Art, F1997.8

Belonging to a series celebrating the Hindu goddess, this painting was created around 1670 as a tool for meditation accompanied by a mantra, the sacred syllable "*bhaim.*" It depicts the moment when the fierce Bhadrakali assumed a gentle form in response to the meditation of the sage Chyavana. On the left, the bearded Chyavana holds a garland of prayer beads in his hand as he gazes intently at the golden-skinned goddess. Wearing vivid yellow garments and a crown adorned with emeralds and lotus flowers, she holds the attributes of the god Vishnu—lotus, conch shell, mace, and discus—in her four hennaed hands. While the sage meditates within a forest hermitage of fantastic trees, the goddess appears against an indeterminate field of color. However, the sprawling male corpse on which she sits evokes a cremation ground, the preferred haunt of the terrifying Bhadrakali.

With its pulsating colors, lotus-eyed figures, and forms that project into the painting's borders, the image has an aura of spiritual intensity. The emeralds worn by the goddess and sage are made from beetle-wing cases that cause the painting to glimmer with untamed magnificence. In spite of the work's fierceness and two-dimensional composition, its supple line and luminous application of paint reveal great poise. In fact, the series is among the earliest painted manuscripts from the small kingdom of Basohli in the Himalayan foothills; the sudden emergence of this powerful style remains a mystery.

Like most Hindu manuscripts, the pages of the Tantric Devi series were unbound, and viewers lifted the folios one by one to appreciate them. The central image is protected by painted red borders, which bear notations in a local script called Takri that identify the goddess, her devotee, and the folio's number within the series.

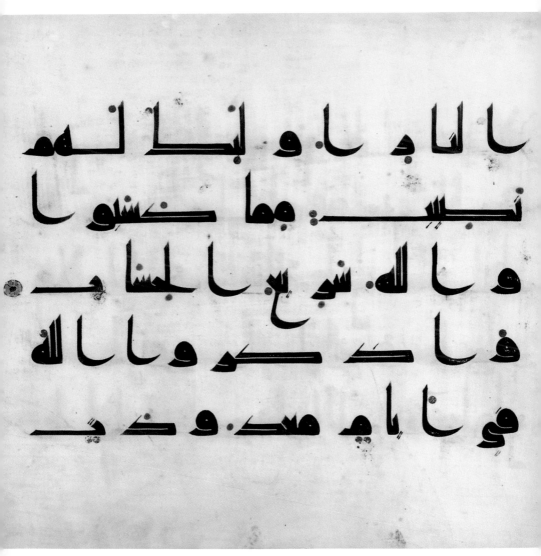

Folio from a Koran

Sura 2:201–3

Near East or North Africa, Abbasid dynasty, 9th century

Ink, color, and gold on parchment; 23 9 x 33.6 cm

Freer Gallery of Art, F1937.6, f.9a

Written with razor-sharp precision, the carefully spaced words move across the smooth, cream-colored surface with a measured pace, as though emulating the steady rhythm of Koranic recitations. The folio is copied with a reed pen in dark brown ink in the so-called Kufic or angular script, a name derived from the city of Kufa in Iraq, a renowned early center of learning and scholarship. The script's relatively short verticals and elongated horizontals, which are further accentuated by the parchment's format, are standard features of the Kufic script.

Comprising one hundred fourteen chapters, the text of the Koran is further subdivided into sections; here, the gold medallion in the margin indicates the end of a verse. Along with the red diacritical marks, which were added for vocalization, the medallion relieves the restrained elegance of the Kufic script. The passage—which asks God to provide righteousness in this world and the next—is from the Koran's second chapter (sura), titled the Cow (al-Baqarah), and is considered a summary of the sacred book's critical principles.

In the ninth century, Kufic was used not only to copy the Koran, Islam's divine message, but also for inscriptions on buildings, textiles, and portable objects, such as ceramics, glass, and metalworks. Although stately and dignified, the script was difficult to read, and with the rapid spread of Islam, it soon was replaced by a series of more legible cursive styles. Kufic continued to be used for headings or single inscriptions, to add graphic accents to a surface.

Lion, Ch'i-lin, and Dragon Set in a Floral Spray

Turkey, Ottoman period, mid-16th century
Ink, color, and gold on paper; 17.5 x 28.6 cm
Freer Gallery of Art, F1948.17

Fantastic animals in ferocious combat were a recurring theme in art from
sixteenth-century Ottoman Turkey. This remarkable drawing was executed
with a reed pen in the so-called *qalam siyahi* ("black pen") style, and then
highlighted with washes of color and gold accents. On the right, a lion—its
body reduced to a swirl of tight curls—devours a *ch'i-lin*, a mythical Chinese
animal. On the left, a menacing dragon is about to swallow a bird perching
helplessly on its tongue. The dragon clutches a flowering scroll, which
resembles a noose as it circles the lion. The artist's masterful use of
calligraphic lines that coil, twist, expand, and contract infuses the
composition with pulsating tension and excitement. Both the *ch'i-lin* and
the dragon were inspired by Chinese models, but the depiction of these
animals as fearsome, battling creatures is characteristic of pictorial traditions
in Ottoman Turkey.

The style of drawing has been linked to the Iranian artist Shah Quli,
who worked at the Ottoman court circa 1520–60. While the drawing's
exact meaning remains elusive, such animal combats were popular in both
Turkey and Iran, offering artists ideal opportunities to explore the graphic
potential of pure line drawing.

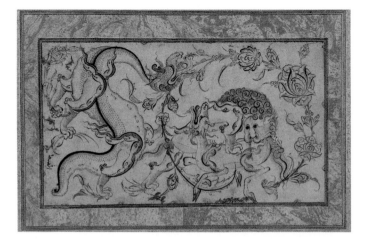

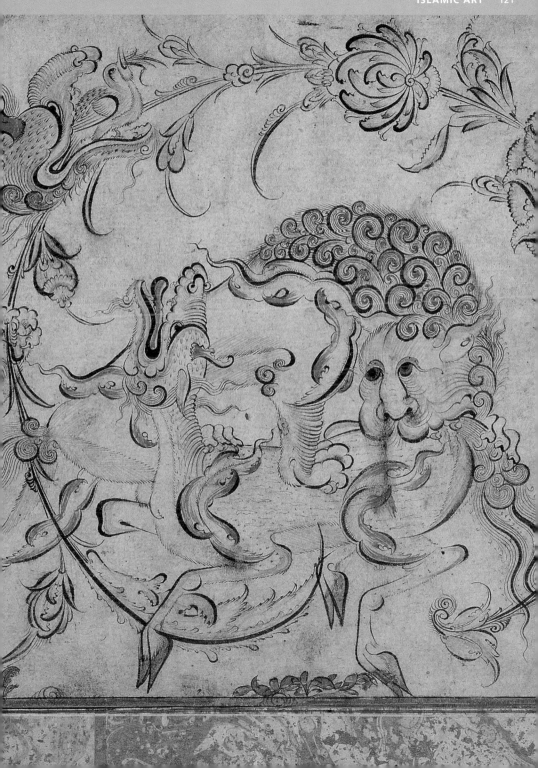

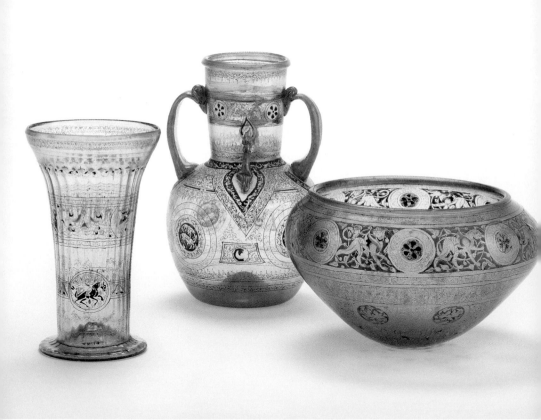

Tall Beaker

Syria, late 13th century
Gilded and enameled glass; 29.5 x 17.2 cm
Freer Gallery of Art, F1948.14

Vase

Syria, 1325–50
Gilded and enameled glass; 36.2 x 23.4 cm
Freer Gallery of Art, F1934.19

Bowl

Syria, second half of the 14th century
Gilded and enameled glass; 21 x 35 cm
Freer Gallery of Art, F1933.13

Gilded and enameled glass vessels were among the most treasured luxury goods in the medieval Islamic world. Produced in thirteenth- and fourteenth-century Syria and Egypt, they epitomize the technical sophistication and artistic skills of local craftsmen. Once the glassmaker had created his vessel, he would apply the powdered enamel—made from opaque, colored glass suspended in an oily medium—to the surface with a brush or reed pen. The vessel then was reheated to fix the enamel and gold to the surface. Although the colors and gold required different temperatures to fuse to the surface, these glassmakers may have developed a method that allowed them to adhere all the colors at once.

As suggested by the three impressive examples in the Freer collection, the motifs ranged from figurative designs, such as fantastic animals, to elegant calligraphic inscriptions. In the fourteenth century, motifs outlined in red, gold, and blue predominated, and the objects tended to be relatively large in scale.

The five-petal rosettes on two of the vessels confirm that they were intended for the Rasulid court of Yemen (reigned 1229–1454). They may have been royal gifts or were commissioned by the Yemeni rulers and decorated with their dynastic emblem. Such luxurious enameled glass vessels circulated well beyond the Islamic world; the large vase, for example, reportedly was discovered in China.

Ardashir Captures Ardavan

Folio from a *Shahnama* (Book of kings) by Firdawsi (d. 1020)
Tabriz, Iran, Ilkhanid period, ca. 1330–40
Opaque watercolor, ink, and gold on paper; 59.2 x 39.7 cm
Purchase—Smithsonian Unrestricted Trust Funds, Smithsonian Collections
Acquisition Program, and Dr. Arthur M. Sackler
Arthur M. Sackler Gallery, S1986.103a-b

When Ardavan, the last Parthian ruler (reigned 247–224 BCE), heard that
Ardashir—the son of a local princess and a shepherd, the founder of the
subsequent Sasanian dynasty (224 BCE–651 CE)—had surpassed his own
son in hunting, he challenged Ardashir to combat. This painting depicts
the moment when a wounded Ardavan finally has been captured after
forty days of fighting and is brought before Ardashir. With hands tied
behind his back, downcast eyes, and slumped shoulders, Ardavan
symbolizes pathos and defeat, which contrasts sharply with the proud
and erect figure of Ardashir on a white steed. As agitated horses gallop
towards him, and the dry, twisted branches of a large pine seem to recoil,
a dejected Ardavan quietly contemplates his fate. In the center, a Mongol
soldier, perhaps Ardavan's executioner, leans on his mace and has turned
his back to the viewer. He stands just across the ruled edge of the painting,
lending the composition a distinct theatricality and heightening its intense
emotional drama.

The illustration belongs to one of the earliest and most important
illustrated copies of the *Shahnama* (Book of kings), Iran's national epic,
written in some fifty thousand lines of verse by the poet Firdawsi circa 1010.
This particular copy was illustrated in the 1330s during the reign of the
Mongol Ilkhanid dynasty (1256–1353). Its fifty-eight extant illustrations are
now dispersed among public and private collections. They are considered
a watershed in the history of Iranian manuscript painting and are remarkable
for their stylistic originality, compositional complexity, and emotional
expressiveness. Today, the Freer and Sackler Galleries hold the largest
number of pages from the "Ilkhanid" *Shahnama*, including the folio
presented here.

Khusraw at the Gate of Shirin's Castle

From a *Khusraw and Shirin* poem by Nizami (d. 1209)
Copied by Ali ibn Hasan al-Sultani
Iran, Tabriz, early 15th century
Opaque watercolor, ink, and gold on paper;
25.7 x 18.4 cm
Freer Gallery of Art, F1931.36 recto

The romance of Khusraw and Shirin ranks among the great masterpieces of Iranian literature and is the second of five poems in the *Khamsa* (Quintet) by the poet Nizami. A favorite subject for painters after the late fourteenth century, the poem narrates the adventures of the Sasanian king Khusraw Parviz (reigned 590–628) and the Armenian princess Shirin, renowned for her intelligence, loyalty, bravery, and beauty. The story begins with Shirin falling in love with an image of Khusraw, while the king's passions are kindled by descriptions of the princess. The two finally meet only to be separated repeatedly because of Khusraw's fickleness and cruelty.

This delicate painting is from one of the earliest extant illustrated copies of Nizami's poem and represents a momentous encounter between the two lovers. Displeased with Khusraw's behavior and his marriage to another woman, Shirin has withdrawn to her castle. Following the death of his queen, Khusraw attempts to see Shirin, who finally yields to his request. Shielded by a parasol, the sign of kingship, Khusraw arrives at Shirin's castle, where the ground is covered with precious textiles and brocades, and servants rush out to greet him with trays of gold coins. Oblivious to the tribute, the king gestures in supplication toward Shirin, who gazes down from the window of her blue-tiled castle. Nizami's text specifies that Khusraw arrived at dawn in the dead of winter, but the artist has depicted the reunion in a blossoming garden, under the warm light of a waning moon. This verdant, idealized setting seems far more appropriate, and even the exuberant floral sprays echo the couple's temporary happiness. The painting's brilliant palette, minute details, and sumptuous textures exemplify the lyricism and refinement of late fourteenth- and early fifteenth-century painting, which became the foundation for the Iranian pictorial tradition.

Bowl

Iran or present-day Uzbekistan, Samanid dynasty, 10th century
Earthenware painted under glaze; 11.2 x 39.3 cm
Freer Gallery of Art, F1957.24

In the tenth century, eastern Iran and present-day Uzbekistan became the center for the production of some of the most remarkable epigraphic ceramic wares inscribed with moralizing proverbs in Arabic. These vessels are important not only for their message but also for their artistic and technical sophistication. The buff-colored earthenware body was covered with white slip (a semi-fluid colored clay) to create the ground color. For the design of this particular bowl, the artist used ochre and black-colored slips, and then followed up with a transparent glaze.

Centered on a small rosette, the extraordinary decoration comprises a tree trunk that separates into five swirling branches, each one also curling into an elegant rosette. Their strong, clockwise movement echoes the direction of the inscription along the bowl's perimeter. Written in an elegantly paced angular or Kufic script, it begins at the small ovoid mark on the left and reads, "It is said he [who] is content with his own opinion runs into danger. Blessing to the owner."

The exact use of epigraphic bowls is yet to be determined, but they remain some of the earliest and most sophisticated written sources for Arabic proverbs and aphorisms.

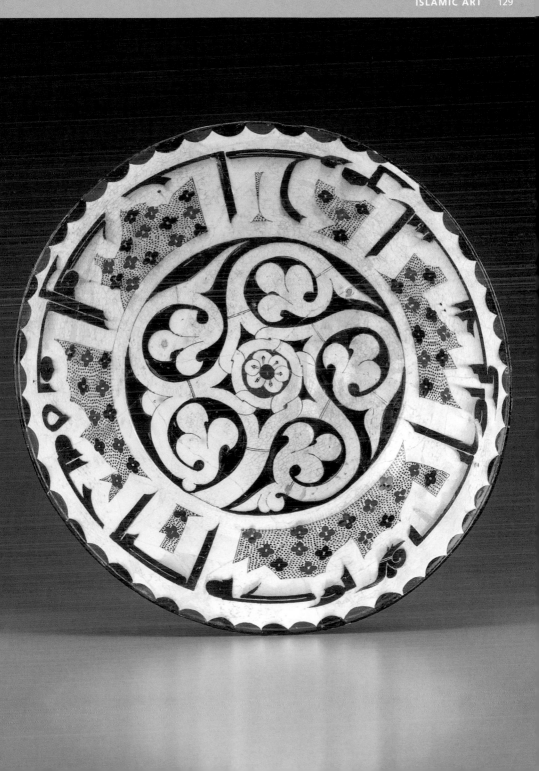

Double folio from a Koran

Iran, Shiraz, Safavid period,
ca. 1525–50
Opaque watercolor, ink, and gold
on paper; 42.4 x 50.1 cm
Purchase—Smithsonian Unrestricted
Trust Funds, Smithsonian Collections
Acquisition Program,
and Dr. Arthur M. Sackler
Arthur M. Sackler Gallery,
S1986.82.1–2

During the sixteenth century, the
city of Shiraz in central Iran was
associated with some of the most
lavishly illuminated religious and
secular manuscripts ever produced.
Now detached, this double folio
originally must have belonged to a
copy of the Koran, and its central
gold medallions are inscribed with
the first sura, *Fatiha*, which evokes
God's guidance and mercy.
Illuminated frontispieces, included
in Korans since the tenth century to
distinguish the beginning of the text
from the rest of the volume,
became increasingly elaborate
over time.

This double page has been attributed to Ruzbihan Muhammad al-Tab'i al-Shirazi, one of the most accomplished calligraphers and illuminators of the period. Descended from a family of artists, his works include religious and historical texts as well as individual calligraphic samples. Apart from his ornate style of illumination, Ruzbihan also stands out among his peers for working at a dervish in Shiraz. His intricately detailed design of cloud bands, interspersed with minute flowers and fine gold spirals, creates an unparalleled sense of sumptuousness, which also serves as a foil to the beauty of the divine message.

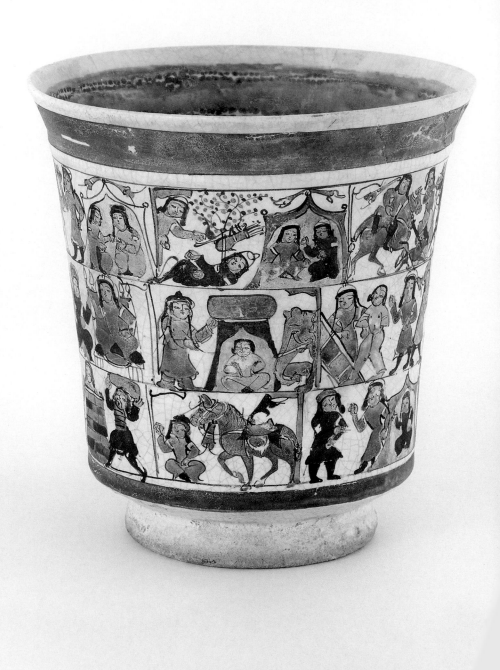

Beaker

Iran, Seljuq period, early 13th century
Stone paste painted over glaze with enamel (*minai*); 12 x 11.2 cm
Freer Gallery of Art, F1928.2

Modest in size, this vessel is one of the great masterpieces of Iranian ceramics. The only known example of its kind, it is decorated with an entire narrative cycle—the romance of Bijan and Manija from the *Shahnama* (Book of kings) by Firdawsi (died 1020). The design, which recalls modern graphic novels, is divided into twelve episodes organized in three horizontal registers. Moving from right to left, it begins with Firdawsi joining his beloved in a tent and telling her the story. It then proceeds with scenes of Bijan's wild boar hunt and his meeting of Manija, the daughter of the Turanian king Afrasiyab. When the king learns of the liaison, he becomes enraged, imprisons Bijan, and throws him into a well. The great Persian hero Rustam hears about the incidents and comes to Bijan's rescue by lifting the giant rock covering the well. Apart from its highly original format, the decoration represents the earliest and most comprehensive cycle of illustration of this famous story, some one hundred years before its appearance on paper. The beaker also includes the earliest representation of the poet Firdawsi.

The spontaneously drawn scenes are executed in what is known as the overglaze painting technique. It allowed potters to "color" their compositions with enamel (*minai*), which was fixed to the surface with a final low-temperature firing, resulting in a series of complex and colorful scenes and motifs otherwise possible only on paper.

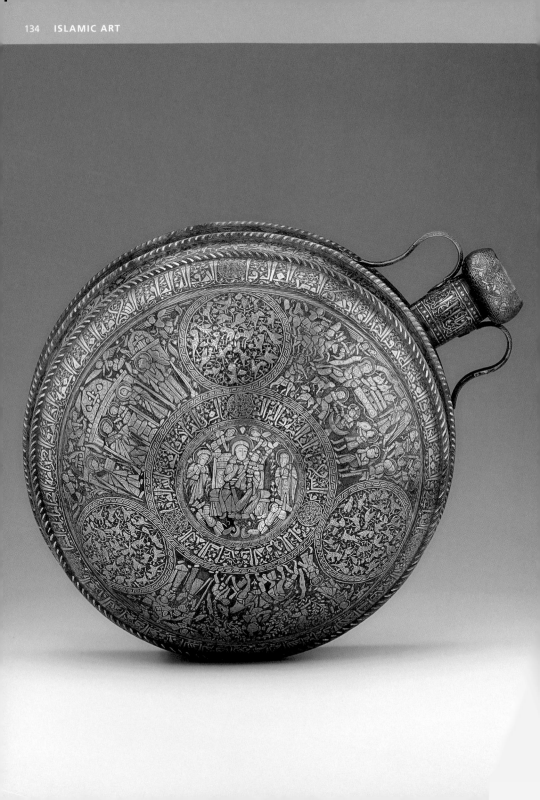

Canteen

Probably northern Iraq, Ayyubid dynasty, mid-13th century
Brass with silver inlay; 45.2 x 36.7 cm
Freer Gallery of Art, F1941.10

The large and imposing canteen, inlaid with silver, is the most celebrated of eighteen brass objects that integrate pictorial, calligraphic, and abstract motifs characteristic of medieval Islamic metalwork with a series of Christian images. A central medallion on the concave front represents the Virgin and Child and is framed by an inscribed band of blessings, which acts much like a halo. The outer zone includes four finely detailed scenes from the life of Christ—the Nativity, Baptism, entry into Jerusalem, and presentation in the temple—separated by three medallions filled with stylized animal and bird motifs. The Christian themes are continued on the flat back in two bands encircling a central socket. Although the canteen is also decorated with inscriptions, these consist of anonymous blessings and unfortunately do not identify the patron of this exceptional work of art.

The canteen's style and technique epitomize the artistic and technical sophistication of medieval metalworkers under Ayyubid rule (1171–1250) in Syria and northern Iraq, home to a multitude of Christian communities. Its decorative synthesis attests to the creative exchange of artistic ideas and traditions between Muslim and Christian communities and the development of a dynamic shared visual culture. It has been proposed that this canteen may have been intended as a souvenir, perhaps as a container for holy water or oil.

Young Prince
Signed by Muhammad Haravi
Historic Iran, present-day Afghanistan, Herat, 1560s
Opaque watercolor and gold on paper; 34.1 x 24 cm
Freer Gallery of Art, F1937.8

After the late fifteenth century, Iranian artists created autonomous paintings and drawings that were gathered in albums, a tradition that also spread to India and Turkey. Like this meticulously dressed youth, most album page paintings comprised idealized men and women, frequently portrayed in a quiet, contemplative mood with such props as books, wine cups, or flowers. While these compositions did not relate directly to a specific text, they can be interpreted as visual metaphors and evocations of a Iranian poetic conceit, for example, youthful beauty, the solace of wine, or yearning for the beloved.

This youth, the epitome of style and refinement, wears a vibrant orange robe and an elegant white turban associated with the first half of the sixteenth century. His elaborate, fur-lined coat, characteristic of fine Safavid figural textiles, belies his meditative expression. Warriors dragging prisoners across a landscape, including a woman in the lower right, lend the otherwise serene composition a sense of disquiet, tension, and mystery.

The painting is signed by Muhammad of Herat (Haravi), also known as Muhammadi, one of the most accomplished painters of the later sixteenth century. He was recognized for his fine draftsmanship and highly controlled palette, elements that are also evident here.

Boy Viewing Mount Fuji

Katsushika Hokusai (1760–1849)
Japan, Edo period, 1839
Hanging scroll, ink and color on silk; 36.2 x 51.2 cm
Gift of Charles Lang Freer
Freer Gallery of Art, F1998.110

Hokusai sought inspiration, especially in his later years, in the sacred Mount Fuji, which dominated the distant horizon of Edo (now Tokyo). The soaring peak, an active volcano that concealed its imminent power beneath snow and clouds, attracted pilgrims and worshipers. The landscapes in his print series *Thirty-Six Views of Mount Fuji* (*Fugaku sanjūrokukei*)—published between 1830 and 1835 when the artist was in his seventies—includes the most famous image in Japanese art, known popularly as "The Great Wave." In the same period of intense creativity, Hokusai undertook designs for a three-volume masterpiece of book illustration, *One Hundred Views of Mount Fuji* (*Fugaku hyakkei*).

In this engaging painting, a young boy, perched on the trunk of a budding willow, plays a flute as he views the magnificent, snow-capped Mount Fuji. Painted on silk in 1839, the artist's eightieth year, its small format recalls woodblock prints of the period. The painting displays the artist's technical accomplishment, especially in the nuanced gradations of ink and color wash that define the mountain's form, and in its composition, which establishes a remarkable empathy between the viewer and the subject. The boy's back is to the viewer, who shares his contemplative gaze toward the majestic mountain.

Boy Viewing Mount Fuji was among the first group of paintings by Hokusai that Charles Lang Freer purchased. Influenced by his advisor Ernest Fenollosa (1853–1908) and deeply impressed by the beauty of the works, Freer intensively pursued the artist's paintings for a decade, turning away from his early interest in Japanese prints. Recent scholarly studies have confirmed that today the Freer Gallery of Art holds the world's most extensive collection of Hokusai's paintings, representing all periods of the Japanese master's activity.

Nirvana of the Historical Buddha Shakyamuni

Japan, Kamakura period, early 14th century
Hanging scroll, ink, color, gold, and silver on silk; 195.8 x 189.1 cm
Freer Gallery of Art, F1970.30

The historical Buddha Shakyamuni reached the end of his physical life at
Kushinara (present-day Kushinagar) in India. His death released him to
nirvana from the endless cycles of rebirth and consequent suffering.
Images of his last transformative moment first occurred in the context of
depictions of important episodes in the life of the Buddha. Stone relief
sculptures established the elements of the scenes that were transmitted
with the Buddha's teachings through many regions of Asia by generations
of faithful disciples (see pages 96–99).

The earliest Japanese image of the nirvana of the Buddha, dated 711,
is a clay sculpture in the five-storied pagoda of the Hōryūji Buddhist temple
in Nara. In Japan, paintings commemorating the Buddha's final teaching,
death, and nirvana were displayed at ceremonies held every February. In
this fourteenth-century painting, the Buddha lies on his right side on a
platform surrounded by trees, a composition that faithfully follows the
earliest Japanese representations of this scene. Mourners include
bodhisattvas, who share the Buddha's enlightenment, disciples, monks,
laypeople, gods who have become followers of his teaching, and animals.
All express their profound grief at his death because they do not fully
understand the meaning of his peaceful release from his physical body.
Maya, the Buddha's mother, descends on clouds from above.

The scale and splendor of this painting, particularly the rich mineral
gold and silver colors on silk, present the fundamental lesson of the
Buddha's final teaching in readily understandable imagery. Details closely
resemble a work by the artist Myōson dated 1323 and now in the Fujita
Museum in Osaka, Japan. The Freer painting, which once was in the
Enmeiji, a Buddhist temple in Ise province, likely was produced by an atelier
of Buddhist painters at the Kōfukuji in Nara where Myōson worked.

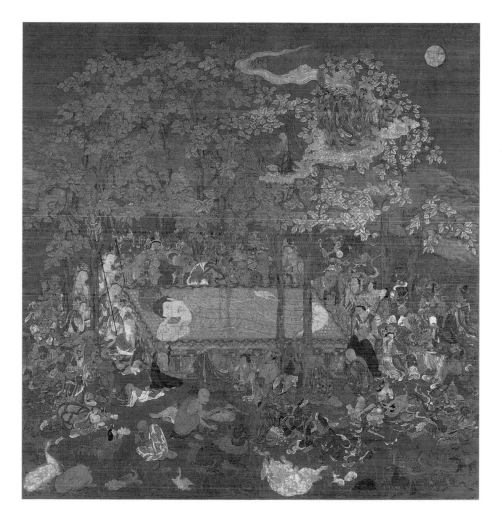

Bodhisattva

Kaikei (act. ca. 1185–1220)
Japan, Kamakura period, early 13th century
Wood with lacquer, gold, and crystal; 62.8 x 43.2 x 38.1 cm
Gift of Charles Lang Freer
Freer Gallery of Art, F1909.345

In the early Kamakura period (1185–1333), several Buddhist temples in
Nara, the capital of Japan from 710 to 784, undertook major rebuilding
projects. The goal was to recover from damage inflicted during the wars
between the Taira and Minamoto families that ended with the victory of
Minamoto Yoritomo (1147–1333) and his establishment as the first shogun.
The state-sponsored preservation of early temple buildings and sculpture
from this formative period of Japanese Buddhism constituted a rich
repository of models for sculptors and architects of new commissions.

Based on its style and a signature cipher in the hollow cavity, this
seated bodhisattva, a compassionate Buddhist deity who responds to the
needs of the suffering, recently has been identified by scholars as an early
work by the master sculptor Kaikei. He was a one of a lineage of sculptors
who worked on rebuilding projects for the Buddhist temples Tōdaiji and
Kōfukuji, which both held extensive collections of Nara-period sculpture.
After the renovation was completed, the Kaikei studio was moved to
Kyoto, where it established a graceful, technically accomplished style that
represented a major development in the history of Japanese religious art.
During this period, artists used rock crystal insets over the eyes of the gilded
and polychromed wood sculptures to create a realistic appearance.

Charles Lang Freer acquired this sculpture from the art dealer Nomura
Yōzo, whose shop, Samurai Shōkai, was located in Yokohama. At that time,
the bodhisattva was attributed to the artist Unkei (died 1223), who had
collaborated with Kaikei on the dynamic guardian sculptures of the
Nandaimon (Great South Gate) of Tōdaiji. The bodhisattva is one of a
small but distinguished collection of Japanese Buddhist sculpture, ranging
in date from the seventh to the nineteenth centuries, now in the Freer
and Sackler Galleries.

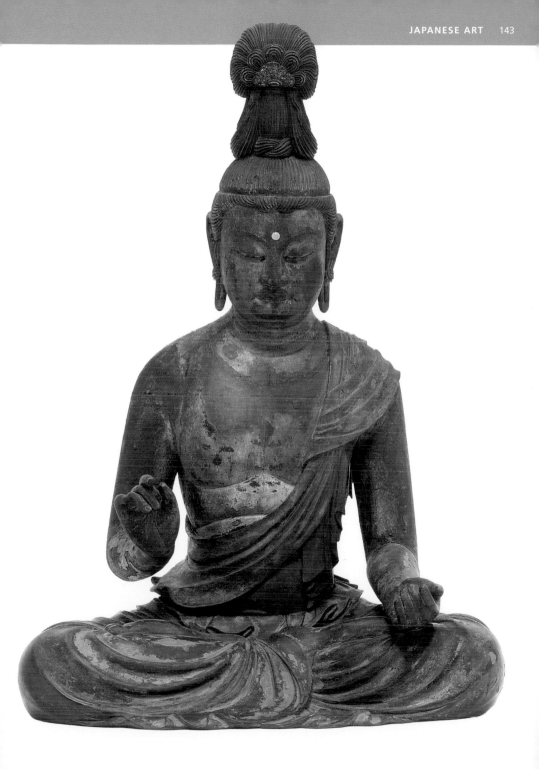

Poems of Ki no Tsurayuki

From *Anthology of the Thirty-Six Poets*
Calligraphy attributed to Fujiwara no Sadanobu (1088–1156)
Japan, Heian period, early 12th century
Album page mounted on a hanging scroll, ink on joined paper,
gold and silver; 21.2 x 16.1 cm
Freer Gallery of Art, F1969.4

During the Heian period (794–1185), Japanese calligraphers developed a distinctive artistic script known as *hiragana*, based on the cursive forms of Chinese characters. Simplified beyond Chinese prototypes, the graceful forms of the Japanese cursive script were adapted to represent the phonetic syllables of the Japanese language. By the eleventh century, the script had become a repertoire of visually varied and graceful forms that were especially suited to personal correspondence and poetry. Both men and women of the imperial court cultivated the culturally valued skills of composing poetry and creating aesthetically pleasing calligraphy.

The high esteem for calligraphy created a demand for fine handmade and decorated paper to be used for projects ranging from small albums or scrolls to lavish multi-volume works. This page, from a volume dispersed and sold in 1929, is from a set of thirty-nine books containing a transcription of the *Anthology of the Thirty-Six Poets* (*Sanjūrokuninshū*) in the collection of the Kyoto Buddhist temple Nishi Honganji. Collectively, these volumes express the refined taste of Japanese aristocrats in the late Heian period.

The page was created by joining three cut and torn pieces along their edges. Each sheet was dyed a different color, and the assembled page was decorated with flecks of gold and silver leaf in addition to painted designs of scattered grasses and birds in silver. Two poems by Ki no Tsurayuki (872?–946) almost seem to float across the patterns. The lines of these elegies for a friend are written vertically and read in columns beginning at the upper right.

kinou made	a beloved friend
aimishi hito no	I met until yesterday
kyo naki wa	is gone today
yama no kumo to zo	swept away
tanabiki ni keru	by mountain clouds
ukeredomo	
ikeru wa sa	although we receive
te mo arumono wo	life, alas!
shinuru nomi koso	when he died
kanashi kari kere	how great my grief.

Cranes

Itō Jakuchū (1716–1800)
Japan, Edo period, ca. 1775–90
Pair of hanging scrolls, ink on paper;
143.3 x 67.5 cm (left), 143.5 x 68 cm (right)
Purchase—Mary Livingston Griggs and Mary Griggs Burke Foundation
in honor of the 75th Anniversary of the Freer Gallery of Art
Freer Gallery of Art, F1997.25.1, F1997.25.2

These magnificent, large-scale, abstract forms of cranes facing each other
are rendered with versatile brushwork entirely in tones of ink. An unusually
striking technique of building forms with brushstrokes and leaving
unpainted areas between depicts the gray feathers of the crane at left and
the full chrysanthemum blossoms at right. Wet and dry strokes suggest
plumage. Crisp, dark contours on the rocks and in the feathers of the
cranes accentuate the compositions.

Itō Jakuchū lived and painted in Kyoto during a period of great artistic
vitality. Removed from the popular culture that flourished around the
shogun's castle in Edo (Tokyo), Kyoto remained a center of cultural pursuits,
religious institutions, and learning. Schools of artists studied newly imported
works from China and Europe as well as the native painting styles of Japan.
Jakuchū first worked in the family business, a greengrocery in Kyoto, but
contemporary accounts describe him as reclusive and solitary. He became
interested in Zen Buddhism and established a close friendship with the
monk Daiten (1719–1801). The natural world became an expression of
his devotion to Buddhist teachings as well as the dominant subject of his
distinctive paintings, which are characterized by technical virtuosity and
dramatic compositions, whether painted in full color on silk, like his
thirty-scroll series Dōshoku Sai-e (Colorful Realm of Living Beings), or in ink,
as in this pair of hanging scrolls. These paintings by a major Japanese
painter of the eighteenth century significantly enhance the museums'
extensive collections of Edo-period paintings, ceramics, lacquer, prints,
and printed books.

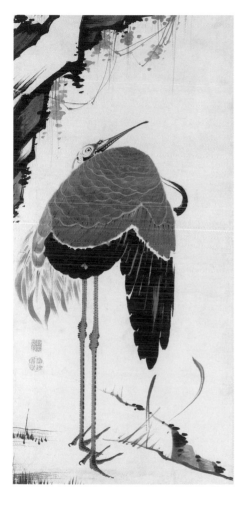

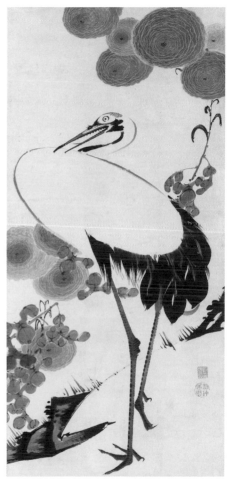

Self-portrait

Kohno Michisei (1895–1950)

Japan, 1917

Oil on canvas; 91.2 x 65.3 cm

Gift of Shuntatsu Kohno and the Kohno family in memory of their father

Arthur M. Sackler Gallery, S1998.115

A self-portrait by German artist Albrecht Dürer (1471–1528), dated 1500 and now in the Alte Pinakothek in Munich, was the model for Kohno Michisei's own self-portrait at the age of twenty-two. Western painting had become an important line of development in Japan during the late nineteenth century as the country entered into full commercial and cultural relations with Europe and the United States. For the first time, aspiring artists had access to expert training in both Japanese and European methods. Michisei was the son of the painter and portrait photographer Kohno Jirō (1856–1934), who had studied oil painting with Takahashi Yuichi (1828–1934), a leading painter who had been trained by foreign artists based in Japan. The younger artist also discovered images of famous Western paintings through reproductions in books, and he encountered religious icons after his father joined the Russian Orthodox Church and shared an interest in Northern Renaissance portrait styles with the painter Kishida Ryūsei (1891–1929), whom he met in 1915. Ryūsei was already well known for his paintings, including portraits in which he sought to combine Western and Japanese ideas.

Michisei's direct frontal gaze, a feature inspired by Dürer's work, is a striking departure from the traditional three-quarter view that Japanese artists preferred. The artist observed his own features accurately, even depicting the way his spectacles magnified his weak right eye. Over his kimono he wears a fur-collared coat, a combination of traditional Japanese and Western dress that was common at the time; he holds a painter's glove in his folded hands.

Given to the Arthur M. Sackler Gallery by his family, this is a deeply affecting image of a young artist confidently painting in a newly assimilated artistic tradition. Although Michisei worked as an illustrator and writer after he moved from Nagano to Tokyo in 1917, this painting eloquently expresses the emotive power of his early portraits.

Kiyosu Bridge

Kawase Hasui (1883–1957)
Japan, 1931
Woodblock print, ink
and color on paper;
24.2 x 36.5 cm
Robert O. Muller Collection
Arthur M. Sackler Gallery,
S2003.8.761

This nocturnal image of the
Kiyosu Bridge, rebuilt after
the destruction and fires of
the Great Kantō Earthquake
of 1923, reveals the technical virtuosity that the artist's publisher Watanabe
Shozaburō (1885–1962) achieved in executing the artist's designs.
Watanabe employed highly skilled block carvers and printers who could
produce works that resembled paintings through controlled gradation of
color and overprinting. Kawase Hasui excelled in creating paintings and
print designs of landscapes and cityscapes with atmospheric effects, such as
rain, snow, light, and mist.

Part of a collection of more than four thousand prints, paintings, and
archival materials, this print was bequeathed to the Arthur M. Sackler
Gallery by the American collector Robert O. Muller (1911–2003). Muller
purchased his first Japanese print in 1931 while he was a student at Harvard
University. As a collector, patron, and eventually an art dealer in New Haven,
Connecticut, Muller focused on prints of the Meiji era (1868–1912) and by
artists of the Shin-hanga, or "new print" movement fostered by Watanabe.
His collection and related archival information now in the Sackler Gallery are
a major resource for research into Japanese prints of the late nineteenth
and early twentieth centuries. The museum's holdings include other prints
dating from the eighteenth to the late twentieth centuries as well as a major
set of more than two thousand volumes of illustrated books assembled by
the German collector Gerhard Pulverer.

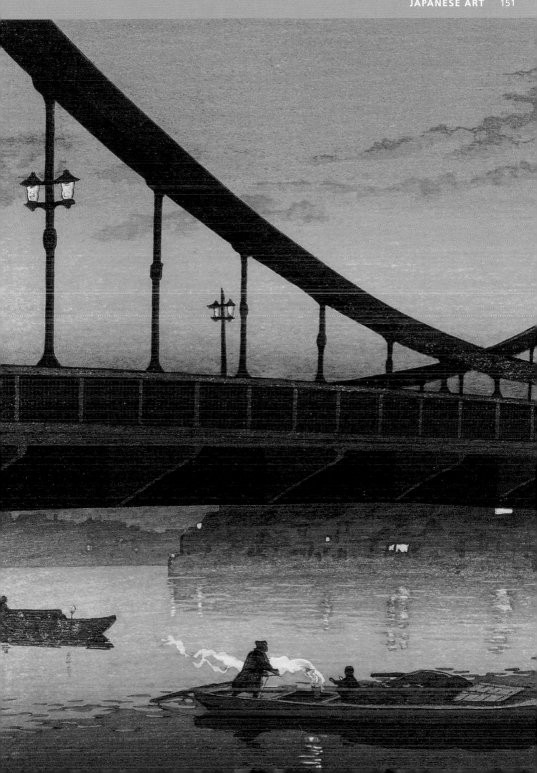

Inkstone box with scene from *The Tale of Genji*

Japan, Edo period, 17th century
Lacquer on wood with gold and silver,
gilt silver water dropper, stone;
18.4 x 16.9 x 4.2 cm
Purchase—Edith Ehrman Fund
Freer Gallery of Art, F1991.9a-d

Calligraphy was an important mark of personal learning and aesthetic sensibility in Japan. Portable lacquered wood boxes were designed to hold an inkstone and water dropper in the base, with trays to hold writing brushes and solid ink sticks. Inkstone boxes (*suzuribako*) could be carried easily to a pleasant location, even outdoors in fine weather, to write correspondence, diary entries, or poetry. Beginning in the eighth century, Japanese artists developed a remarkable repertory of refined techniques for incorporating gold and silver into lacquer decoration. These techniques, known collectively as *maki-e* (sprinkled design or picture), involved the application of gold and silver particles or powders over designs drawn with a brush and liquid lacquer. The distinctive physical properties — adhesion, hardness, and high natural gloss—of natural lacquer from the East Asian lacquer tree *Rhus verniciflua* contributed to the creation of artistic works that were highly valued and carefully preserved for generations.

Maki-e techniques on the lid of this box have been combined to create a masterly picture from *The Tale of Genji,* a classic of Japanese literature from the Heian period. A nobleman's carriage resting in an autumnal field conveys a sense of isolation and melancholy. With extraordinary precision, the lacquer master, whose name is unknown, rendered some motifs in low relief, including the clouds, rocks, flowering grasses, waves, and the carriage itself. The landscape continues inside the box, with a shoreline in moonlight and a gilt silver water dropper in the shape of a boat with waves lapping at its sides. The scale of this small inkstone box resembles album illustrations of *The Tale of Genji,* many of which were commissioned from artists of the elite Tosa school in the seventeenth century, the same period this box was created.

Tea bowl, named Mino-game (Mossy-tailed Tortoise)

Attributed to Hon'ami Kōetsu (1558–1637)
Japan, Kyoto, Edo period, early 17th century
Pottery with black Raku glaze; 8.7 x 12.5 x 12.5 cm
Gift of Charles Lang Freer
Freer Gallery of Art, F1899.34

This deceptively simple deep bowl with wide base and gently flaring walls
represents the ultimate development of the concept of the tea bowl in
Japan. The earliest bowls used for tea drinking in Japan were thrown on
pottery wheels, made in large quantities, and imported from a distant and
unseen source, namely, China. In contrast, this locally produced bowl is an
individual work, sculpted by hand. Moreover, while the bowl was glazed
and fired at the Raku family workshop in Kyoto, its maker was not a
professional potter. In addition to being a sword connoisseur, Hon'ami
Kōetsu was a respected participant in chanoyu (the tea ceremony) as well
as a renowned calligrapher and designer of lacquer objects. Late in life he
collaborated with potters at the Raku workshop to execute a series of tea
bowls in which he developed a deeply personal style. Raku bowls often are
misrepresented as formed from coils of clay; the actual method (derived
from processes used by makers of roof tiles) involved carving the final form
from a thick cylinder of clay. Unlike the uniformity of wheel-thrown vessels,
nuances of the carving in the Raku bowl are apparent to the eye and
especially to the touch of the tea drinker.

Waves at Matsushima

Tawaraya Sōtatsu (act. ca. 1600–1640)
Japan, Edo period, ca. 1625–30
Pair of six-panel folding screens, ink, color, gold, and silver on paper;
152 x 369.9 cm (each screen)
Gift of Charles Lang Freer
Freer Gallery of Art, F1906.231, F1906.232

Matsushima (Pine Islands), a scenic place in Miyagi prefecture in
northeastern Japan, is a famous site (*meisho*) that has inspired poets
through the centuries; it is also a sacred Buddhist pilgrimage destination.
Sōtatsu's interpretation of the subject is highly stylized. The radiant image
of brilliant color and reflected light conveys both the sanctity and beauty of
the site. On one screen, the golden sandbar formed of applied particles of
gold extends across the composition. The silver edges of clouds floating
above the white-capped waves now appear dark from oxidation. Thin lines
of gold and ink alternate to delineate the patterns of the churning waves.
Sōtatsu's signature on these screens includes the title Hokkyō (Bridge of the
[Buddhist] Law), an honorific rank that he received following his first major
commission for wall and sliding-door paintings at the Yogen-in Buddhist
temple in Kyoto.

Only six pairs of large-scale screen paintings—including these screens and another pair of ink paintings of dragons in clouds, in the Freer Gallery of Art—are considered to have been painted by Sōtatsu. Charles Lang Freer bought his works from the Japanese art dealer Kobayashi Bunshichi, who helped Freer develop his peerless collection of paintings by Katsushika Hokusai (1760–1849). Freer's purchase of a folding fan in 1887 inspired his admiration for the painter Ogata Kōrin (1658–1716); he became interested in collecting works by Sōtatsu's occasional collaborator, the renowned calligrapher Hon'ami Kōetsu (1558–1637), and by later artists of the Rinpa (or Rimpa) school, named for Kōrin. It was the simplicity and tonal nuances of Rinpa art that encouraged Freer to acquire paintings and ceramics by the school's major artists and studios.

Tale of Shuten Dōji

Paintings by Kano Shōun (1637–1702)
Calligraphy by Fushiminomiya Kuninaga (1676–1725),
Higashizono Motokazu (1653–1710), and Nakayama Atsuchika (1656–1716)
Japan, Edo period, 1700
Set of three handscrolls, ink, color, gold, and silver on silk;
37.6 x 1880.7 cm (scroll 1, left and pages 158–59),
37.6 x 2334.6 cm (scroll 2, center), 37.6 x 2405.2 cm (scroll 3, right)
Purchase—Friends of Asian Arts
Freer Gallery of Art, F1998.26.1, F1998.26.2, F1998.26.3

In this legendary account, samurai heroes led by Minamoto no Yorimitsu
(948–1021), popularly known as Raikō, conquer the demonic monster
Shuten Dōji, who devours his human victims. Two versions of the story
are named after the purported locales of Shuten Dōji's castle: Ōeyama
(Mount Ōe) and Ibukiyama. Although the story is set in the Heian period
(794–1185), when the imperial court was at a peak of political and
cultural influence, the first surviving evidence of the narrative dates to
the fourteenth century. Fully illustrated versions were produced during
the Muromachi period (1392–1573). A set of scrolls by Kano Motonobu
(1476–1559) became a standard model for later artists of the elite Kano
school, including this set by Kano Shōun, who acknowledged his artistic
ancestor Motonobu in his inscription.

This luxurious set of handscrolls, the longest of which is more than
twenty-four meters long, is dated to 1700 (Genroku 13) in a colophon

that provides the names of three high-ranking calligraphers. Imperial Prince Fushiminomiya Kuninaga, who was related by marriage to retired emperor Reigen (1654–1732, reigned 1663–87), wrote the first section of scroll 1. Major Counselor (Dainagon) Nakayama Atsuchika wrote sections five to seven of scrolls 1 and 2, and Major Counselor Higashizono Motokazu wrote sections two to four of scrolls 1 and 3. Their collaboration with a senior artist of the Kano school strongly suggests that the scrolls were painted for a member of the emperor's or the shogun's household.

Production of handscrolls, illustrated books, kabuki and puppet plays, and paintings of the Shuten Dōji narrative proliferated during the Edo period (1615–1868). The legend's underlying themes—the conquest of a powerful, superhuman adversary by loyal samurai, and its extensive didactic advocacy of belief in Buddhist and Shinto deities—reinforced the political and social ideology of the ruling Tokugawa shoguns in an accessible and popular form.

Dish in seven-*sun* size

Nabeshima ware
Japan, Saga prefecture, Arita, Edo period, 1690–1720
Porcelain with cobalt pigment under colorless glaze, celadon glaze,
and iron pigment on unglazed clay; 5.7 x 20.3 cm
Freer Gallery of Art, F1964.7

The refined porcelain known as Nabeshima ware, named for the lineage
of daimyo (feudal lords) who were its patrons, was developed in Japan at
a series of specialized kilns near the town of Arita in the second half of the
seventeenth century. This dish (part of a set of identical pieces numbering
twenty or a multiple thereof) represented the peak of accomplishment in
Nabeshima ware, when complex technologies were employed to decorate
pure white porcelain. On this dish, a technically demanding combination
of glazes and pigments depicts a misty marsh, giving the illusion that this
is a painting rather than a vessel for serving food.

Translucent celadon glaze defines the bands
of mist while cobalt pigment under
clear glaze and iron pigment
applied directly on the bare
porcelain clay render
withered reeds growing in
a marshy area in late
autumn. Much to the
delight of the diner,
the process of
consuming choice
morsels of food set
out on a dish of this
design gradually
would have revealed
the scene below. Dishes
of this refinement were
produced at the closely
managed Nabeshima kiln for
use in gift exchanges with other
daimyo and with the shogun (national
ruler) of Japan.

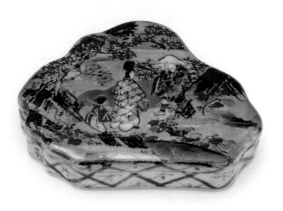

Incense container with design of "Narrow Ivy Road"

Ogata Kenzan (1663–1743)
Japan, Kyoto, Narutaki workshop,
Edo period, early 18th century
White clay with white slip,
cobalt and iron pigments under
transparent glaze, and enamels
over glaze; 2.5 x 10 x 7.3 cm
Gift of Charles Lang Freer
Freer Gallery of Art, F1907.84

Diminutive but meticulously formed and decorated, this box embodies the deep interest in classical literature that was revived in seventeenth-century Japan, especially in the old capital of Kyoto. The scene, known as "Narrow Ivy Road," is an episode from the tenth-century *Tales of Ise*. An exiled Kyoto courtier, walking through distant autumnal mountains, meets a religious ascetic who agrees to carry a letter to a lady who has been left behind in the capital. The cover of the irregularly shaped ceramic box copies a form that was also made in ornamented lacquer and fabric-covered papier-mâché. The box would have been a focal point of conversation at tea gatherings, when the pellets of incense it contained were dropped on coals in the hearth to lend atmosphere to the event. It is an early work from the first pottery workshop established by Ogata Kenzan, a Kyoto textile merchant and connoisseur. Kenzan's better known later work, designed for large-scale commercial production, uses simpler patterns, but his earliest products reflect the high standards of ceramics and other crafts produced for nobility, warriors, and elite merchants in Kyoto.

Bottle

Korea, Goryeo period, mid-12th century
Stoneware with celadon glaze; 28.5 x 18.8 cm
Gift of Charles Lang Freer
Freer Gallery of Art, F1912.96

The development of iron-tinted green or blue-green glaze, known generically in the West as celadon, originated in China and inspired local versions in surrounding Asian countries, including Korea, Japan, Vietnam, and Cambodia. Production of Korean celadon appears to have been assisted by skilled potters who migrated from the kilns that made Yue ware in China's Zhejiang province. Its distinctive appearance resulted from the compositions of local clay and glaze materials. This bottle epitomizes the highest level of Korean ceramic craftsmanship, which even earned the praise of Chinese connoisseurs. Over a fine-grained, light gray body, the translucent glaze appears gray-green with a faint blue tonality. An incised design of two phoenixes flying among peony scrolls covers the entire bottle, and for emphasis a beveled cut captures a deeper thickness of glaze around the outlines of the motifs, like the shading in an ink painting. Molds could be used to produce similar effects on open vessels, such as bowls and dishes, but the decoration on this bottle was executed entirely by hand.

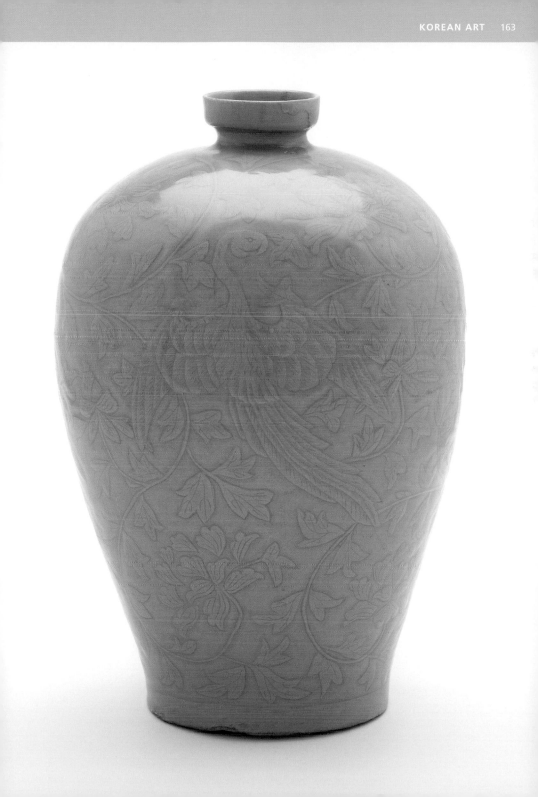

Tea bowl

Korea, Gyeongsamnam-do, Jinju or Sancheong
Joseon period, second half of 16th century
Porcelain with colorless glaze;
gold lacquer repairs; 7.1 x 15.7 cm
Freer Gallery of Art, Gift of Charles Lang Freer, F1905.28

This bowl was made at a provincial kiln in southern Korea, but its current appearance is due to its subsequent importation to Japan, where it was used for drinking powdered tea. Over time, tea tannin created irregular mottling in the clay body, and cracks in the wall—the result of firing or of later damage—were repaired with lacquer sprinkled with powdered gold. The resulting contrast of muted coloration and gold tracery embodied an aesthetic ideal that developed within Japanese tea drinking circles in the sixteenth century; this ideal was represented by the term *wabi,* a flawed beauty that reflected the transience of the material world.

Production of porcelain in Korea developed in two dimensions. A group of central kilns produced fine-bodied white porcelain decorated with underglaze iron, copper, or cobalt painting for the use of the Joseon court, following the model of Ming China. Kilns in the peninsula's southern provinces used local varieties of less-refined porcelain clay to make simpler tableware, predominantly undecorated bowls, dishes, bottles, and jars intended for a regional market and for export. The local clay varieties fired at a lower temperature than the court porcelain and thus were somewhat softer to the touch. Due to impurities in the clay, the color was cream or beige rather than bright white.

Many Korean bowls of this type have been excavated from the sixteenth-century strata of Japanese cities; their delicate glaze colors and generous forms appealed to tea drinkers in Japan. With use over several generations, the bowls developed individualized mottling that was appreciated as a poignant measure of the passage of time. The bowls once were misinterpreted as coarse peasant noodle bowls "discovered" by Japanese connoisseurs, but recent studies of Korean kiln sites have demonstrated that they were made as tableware for local gentry. Moreover, the kilns probably began to make tea bowls to order for the Japanese market in the mid-sixteenth century rather than the early seventeenth century as was once believed.

Kshitigarbha (Jijang)

Korea, Goryeo dynasty, late 13th or early 14th century
Hanging scroll, ink, color, and gold on silk;
107.6 x 49.4 cm
Anonymous Gift
Arthur M. Sackler Gallery, S1992.11

This hanging scroll depicts the bodhisattva
Kshitigarbha, a Buddhist deity who expressed
boundless compassion for those suffering in the long
period between the death of the Historical Buddha,
Shakyamuni (see pages 140–141), and the coming
of the Buddha of the Future, Maitreya. Known as
Kshitigarbha in Sanskrit and Jijang in Korean, he
was widely worshiped throughout East Asia, often
in association with the compassionate bodhisattva
Avalokiteshvara (Kwaneum in Korean) or Amitabha,
the Buddha of Infinite Light who promised believers
rebirth in the Pure Land and release from the cycles
of rebirth and suffering. In Korea, both Kshitigarbha
and Avalokiteshvara were worshiped individually for
their power to mitigate suffering and ensure salvation.
Kshitigarbha was believed to rescue even those whose
sins had condemned them to punishment in hell.

In this painting, Kshitigarbha bears the garments
of a Buddhist priest rather than the princely attire
typically worn by Avalokiteshvara and most other
bodhisattvas. He holds a staff with six rings, which
through their distinctive sound announced the
presence of a Buddhist priest. In his right hand is
a circular gem that has the power to grant wishes.
The elegant refinement of Buddhist paintings of
the late Goryeo dynasty can be seen in the ornate
garments embellished with delicate patterns painted
in gold. The full, voluminous rendering of the figure
and garments creates an impression of realism and
movement, as though the deity, standing on two
lotuses, were floating toward the worshiper.

Ewer

Korea, Goryeo period, mid-13th century
Stoneware with copper pigment and white slip under celadon glaze;
30.5 x 16.7 cm
Gift of Charles Lang Freer
Freer Gallery of Art, F1915.50

This ewer is an elaborate exploration of the formal metaphor of the lotus.
The body is interpreted as two lotus buds, one emerging from the other.
The spout takes the form of a folded lotus leaf. The space between the two
buds contains a small vignette of a lotus pond with a child holding a bud.
(A second child is on the other side.) On the handle, a tiny frog once held
in its mouth the end loop of a chain joined to the now-missing
lid, which was in the shape of the pointed tip of the
smaller bud. The ewer was elaborated with
incised details and further enriched
with outlines of copper-red pigment
and dots of white slip applied under
a clear, even celadon glaze.
 This ewer is virtually identical
to one registered in Korea as a
national treasure that was
discovered in a royal tomb on
Ganghwa Island in Gyeonggi province.
The tomb is variously identified as that of
a prince, Choe U, who died in 1249, or his
son, Choe Hang, who died in 1257.

Bowl with molded decoration

Vietnam, Hanoi or Hai Duong Province, Red River Delta kilns
Later Le dynasty, 15th century
Porcelain with clear, slightly grayish glaze; metal rim; 5.3 x 10.4 cm
Freer Gallery of Art, F1929.82

Sometimes understanding of an object is reached only many years after it
enters a museum collection. This small bowl is formed of porcelain clay
almost as translucent as a frosted light bulb. When the bowl is held up to
light, the motifs of four flying cranes among clouds molded on the inside
around the wall and the six-petal flower in the bottom are visible from the
outside. A thin band of copper protects the delicate rim. When the Freer
Gallery acquired this bowl in 1929, it was thought to be Chinese. It bore
resemblance to porcelains with molded décor made at various places in
China from the Song through the Qing dynasty. Because it had puzzling
differences from any known standard works, however, scholars could not
agree on whether the bowl was a genuine early work, a later imitation,
or a fake from the 1920s.

Only after 2002, when excavations began in the center of Hanoi
on a site that had been the location for successions of government
buildings beginning in the seventh century, did the bowl's identity as
Vietnamese become clear. The stratum that enclosed the remnants of
early fifteenth-century court buildings contained similar porcelain bowls.
Moreover, archaeologists found manufacturing debris
from a ceramic workshop and speculated
that a kiln serving the court may have
operated in the immediate vicinity.
Paper-thin white bowls like the
one in the Freer Gallery may have
been inspired by the preference
for white porcelain vessels at the
Yongle court (1403–1424) during the
Ming dynasty in China. Vietnamese
bowls of similar design but with thicker
bodies are known to have been
manufactured at the kiln complex in the Red
River Delta and have been recovered from a
shipwreck off the coast of central Vietnam.

Lidded jar with four male faces looking in the four cardinal directions, above four female torsos with outstretched hands

Cambodia or northeast Thailand;
Angkor period, late 12th–13th century
White stoneware with iron pigment under wood-ash glaze; 23.5 x 16.2 cm
Gift of Victor and Takako Hauge
Arthur M. Sackler Gallery, S1997.133

Perhaps the most memorable images associated with Angkor Thom, the last capital of the Khmer Empire at Angkor in northwestern Cambodia (802–1431), are the enigmatic smiling faces sculpted in stone and gazing in the four directions that appear above the gateways to the walled city and on numerous towers within the Bayon, the Buddhist temple located at the physical and ritual center of the capital. This ceramic jar bears corresponding appliquéd décor of four male faces on its sloping shoulder. Below the faces are four female torsos representing yoginis, a form of goddess also found in great number in the sculptural ornamentation of the Bayon. The décor associates the jar explicitly with Angkor Thom and seemingly with Jayavarman VII (reigned 1181–?1218), who oversaw the building of the temple and the city. Art historian Peter Sharrock suggests that the jar's iconography links it to rituals associated with that influential ruler.

No other example of a jar with this design is known, and its place of manufacture has not yet been identified. In the twelfth and thirteenth centuries, kilns making glazed stoneware ceramics were operating in what is now northeast Thailand, then part of the Angkorian empire. Since 1995, however, kilns operating closer to Angkor have been excavated within Cambodia. Future research may identify the kiln that produced this jar and others like it.

Goddess

Cambodia, Phnom Bakheng, first quarter of 10th century
Sandstone; 124.2 x 37.5 x 24.3 cm
Arthur M. Sackler Gallery, S1987.909

Although King Yashovarman II (reigned 891–910) ruled for only twenty-one years, he built the "City of Yashodha" (Yashodharapura), one of the foundations of the great Khmer dynasty capital located at present-day Angkor in Cambodia. Yashovarman established the symbolic importance of the imperial city by recreating at its center the cosmic mountain Meru. Known as the Bakheng, the five-tiered temple-mountain was dedicated to the Hindu deity Shiva. Many Khmer rulers worshiped or associated themselves with Shiva, and this imposing female figure may be Uma, the deity's wife, or one of the celestial beauties who dwells on the slopes of Mount Meru. Her elaborate chignon is comprised of thickly looped tresses that resemble Shiva's matted locks. Moreover, the small knob just visible to the right side of her skirt was either connected to a larger image of Shiva or to the end of the lotus flower that the goddess Uma typically holds.

This divine female figure exhibits the reserve and formality characteristic of much of Khmer temple sculpture. At first glance, her restrained expression, firmly erect stance, columnar chignon, and vertically pleated *sampot* convey an aloof presence and a pillar-like immobility. The artist also endowed the figure with smoothly swelling volumes and a gentle expression that create descending countermovements. Her gaze is oriented toward a viewer below, her relaxed belly swells softly downward, and the upper fold of her *sampot* extends into gently curved pleats. The goddess's single, almost horizontal brow, the five palmette-shaped tassels hanging from a sash covered at front by the *sampot*'s folded-over waistband, and the fluid double-knot bow securing the diadem at the back of her head are typical of the Bakheng style.

Carved of a fine-grained sandstone, the sculpture was polished to a smoothly sensuous finish. Areas of refined patterning in the goddess's diadem and skirt provide a pleasing contrast to the supple expanses of her abundant form.

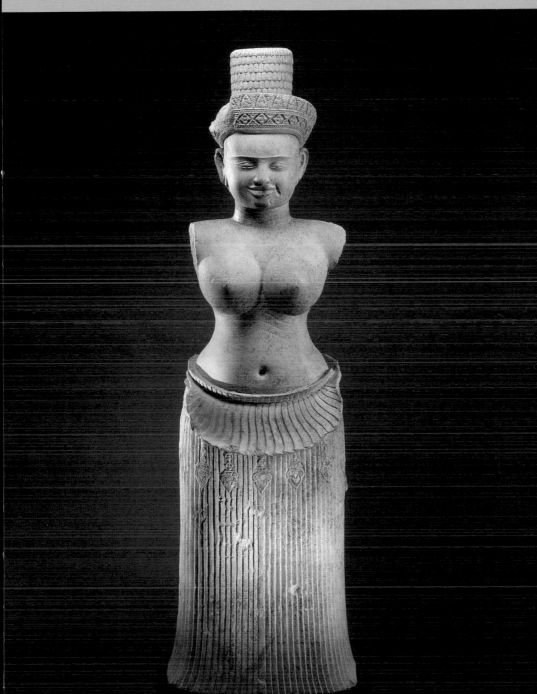

Jar

Vietnam, Hai Doung Province, Red River Delta kilns
Later Le dynasty, 15th century
Stoneware with cobalt decor under transparent glaze;
iron-oxide wash on base; 37 x 23.5 x 23.5 cm
Purchase—Friends of Asian Arts and Smithsonian Collections
Acquisition Program
Freer Gallery of Art, F1992.12

The finely painted decoration on this jar is closely related to motifs on
fifteenth-century Chinese porcelain, although the interpretation and the
appearance of the deep-toned cobalt against the ivory-toned stoneware
body are distinctively Vietnamese. Its shoulder bears a trio of Chinese
mythological beasts separated by flame-like clouds and surrounded by
flames, jewels, and flaming jewels. A peony scroll fills the wide band
around the jar's upper body, and elongated lotus panels cover the lower
half. The base is coated with iron-brown slip. The existence of a distinctive
Vietnamese production of "blue and white"—white-bodied ceramic
decorated with cobalt pigment—was confirmed only in the 1930s when
an inscribed blue-and-white jar in the collection of the Topkapı Saray,
Istanbul, bearing a date corresponding to 1450 and long assumed to be
Chinese, was re-identified as Vietnamese. That jar, like this one, was a
product of a thriving ceramics manufacture that developed around the
capital city of Thang Long (Hanoi) in northern Vietnam. Kilns situated
along the river network of the Red River Delta produced various grades of
ceramics for the court, regional markets, and export. A trove of many
thousands of Red River Delta wares, from the leading center of Chu
Dau and elsewhere, was excavated off the coast of central Vietnam;
it probably had been bound for ports in insular Southeast Asia.

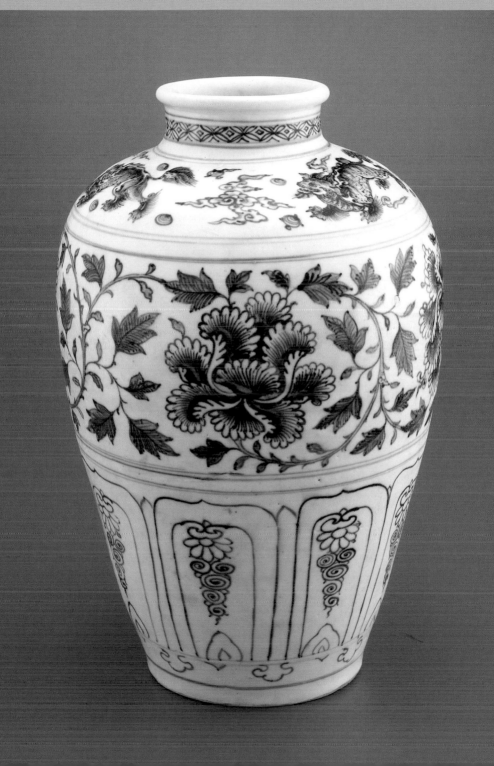

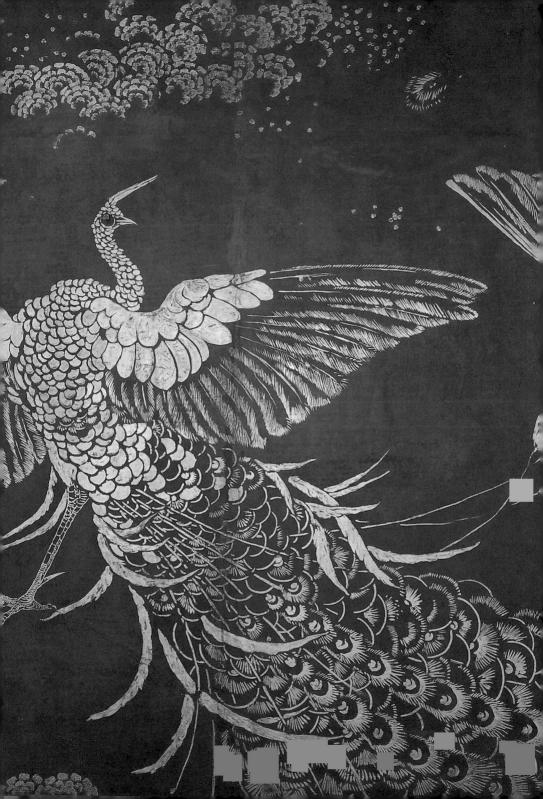

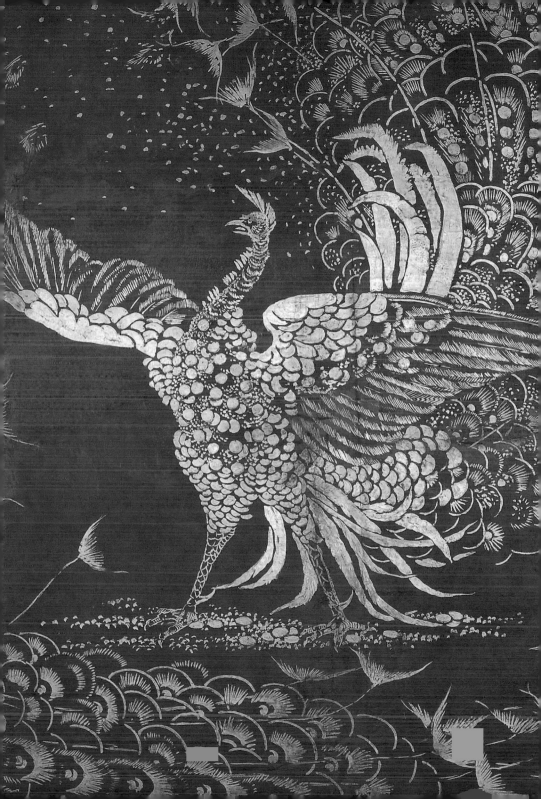

Conservation and Scientific Research

Long before the Freer Gallery of Art opened its doors to the public in 1923, museum founder Charles Lang Freer regularly brought specialists from Japan to care for the Asian artworks on view in his Detroit mansion. These early forays into the care, maintenance, and restoration of Asian art continue today in the Freer and Sackler Galleries' Department of Conservation and Scientific Research.

The Freer and Sackler use a combination of conservation and scientific methods to study works of art. Our scientists and conservators strive to improve methods of preservation, educate others in conservation practices, and conduct research into materials, such as the mineral qualities of jade that help identify sources in China. Their investigations into the makeup of inks and pigments contribute to our understanding of the technological sophistication of Asian cultures in the past and help preserve cherished works of art today. Other areas of scientific research include West Asian ceramics, Southeast Asian stone sculpture, and ancient Chinese bronzes and metalwork.

In 1952 Congress created three positions within the Freer specifically for non-American conservators of East Asian painting. To expand these efforts, Ikuo Hirayama, a leading painter in Japan and an ardent advocate for preserving the world's artistic heritage, established the Hirayama Program for Japanese Painting Conservation in 1999. Participants learn to use traditional tools and materials in combination with modern methods to

"Care and Handling of East Asian Paintings" workshops are conducted regularly at the Freer Gallery and other institutions.

Sukesaku Wakiya, a traditionally trained conservator of Japanese painting, leads the "Japanese Gold Decorating Techniques" workshop in 2007.

preserve Japanese screens and scroll paintings. Their extensive training is complemented by Japanese language studies and several years of working in a painting conservation studio in Japan. Today the East Asian Painting Conservation Studio is one of the most important laboratories outside of Asia, with six conservators on staff who specialize in Chinese or Japanese painting. In addition to training interns and fellows within the department, they also educate professionals at other museums with Asian collections but no appropriate conservators on staff.

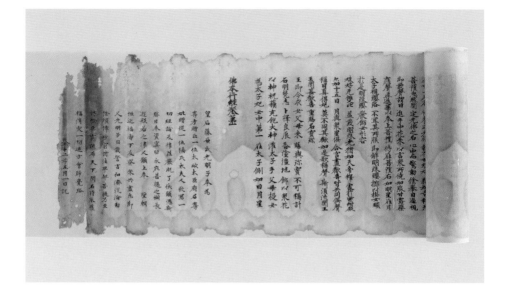

Other recent international collaborations include work with the National Museum of Cambodia on its extensive holdings of stone sculptures and bronzes. The National Museum has made great strides in preserving its unique heritage and, with the Galleries' help, in training Cambodian museum professionals in the care and conservation of its collections. A shared project for technical research also has been developed with the Shaanxi Archaeological Institute in China. Freer and Sackler staff conducts material analysis that would be prohibitively expensive to do in China and contributes to technical studies of Tang-dynasty silver, Han-dynasty ceramics and glass, and Western Zhou-dynasty jades and bronzes.

Our scientists, conservators, and specialists collaborate closely with the museums' design, exhibition, and curatorial departments. Together, they safeguard the collections, ensure the proper display and storage of significant objects, and contribute to the ever-growing understanding and appreciation of Asian and American art.

"May 1st sutra," (detail), Nara period (8th century), after conservation treatment.

Archives

The Archives of the Freer and Sackler Galleries acquires and preserves important research materials to support the museums' role as a center for the scholarly study of Asian art and culture. The Archives houses more than one hundred forty unique research collections (over a thousand linear feet of materials) dating from the early nineteenth century to the present.

The rich holdings associated with industrialist and museum founder Charles Lang Freer form the largest of our collections related to Asian art scholarship and connoisseurship. They include correspondence, personal papers, collection inventories, records of art purchases, scrapbooks, and photographs of his travels in China, Egypt, and Japan. Freer's papers are a major resource for studying the patronage and appreciation of Asian and American art at the turn of the twentieth century. Through his close dealings with painter James McNeill Whistler, the Freer Gallery has the distinction of being the world's leading repository of materials associated with this expatriate American artist.

Kandyan chiefs and government agent, photo by Charles Scowen & Co., ca. 1880. Freer Gallery of Art and Arthur M. Sackler Gallery Archives, A0068.

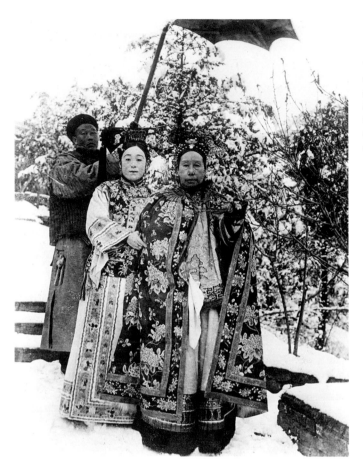

The Empress Dowager Cixi in snow accompanied by attendants, photo by Xunling, 1903–5, Freer Gallery of Art and Arthur M. Sackler Gallery Archives, A0699.

The Archives is also rich in materials related to expeditions to Asia in the early twentieth century. Archaeological expeditions to Iran, Iraq, Turkey, and Syria, conducted between 1903 and 1947, are documented in the papers assembled by archaeologist and art historian Ernst Emil Herzfeld. A respected scholar in West Asia studies, Herzfeld's field notebooks, photographs, drawings, and object inventories record his discoveries at Samarra, Persepolis, and elsewhere. The collection of Myron Bement Smith, a classical archaeologist, architect, and art historian in the twentieth century, similarly record Islamic architecture of Iran. The professional papers of Carl Whiting Bishop document his Freer Gallery–sponsored archaeological activities in China from 1923 to 1934

247 Room,
late 19th century,
Henry and Nancy Rosin
Collection of Photographs
of Japan, Freer Gallery of
Art and Arthur M. Sackler
Gallery Archives, AR358.

and include an unpublished two-volume manuscript, line drawings, rubbings, maps, and nearly four thousand photographs. These document his expeditions in northern and central China, illustrating archaeological sites in the Henan, Shanxi, and Hebei provinces.

Also preserved in the Archives are diverse photographic collections from the mid-nineteenth century to the present, including panoramas of Istanbul and Damascus; still prints of Sri Lanka; photo albums by British officers in India; and a travel journal to Outer Mongolia. Among our photographic collections of China are extremely rare portraits of Cixi, empress dowager of China, taken from 1903 to 1905. Xunling, the son of a senior lady-in-waiting, may have been the only person ever allowed to photograph the empress, and the Archives holds thirty of his original photonegatives. Early photographs of Japan during the Meiji period form

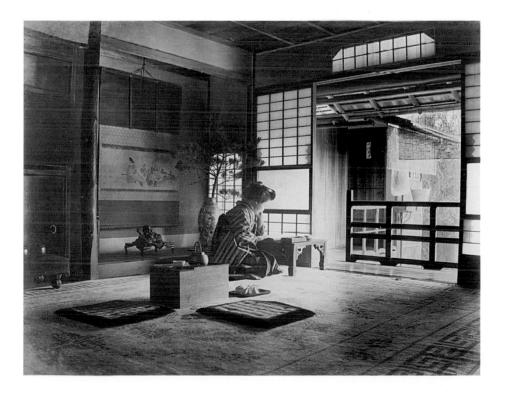

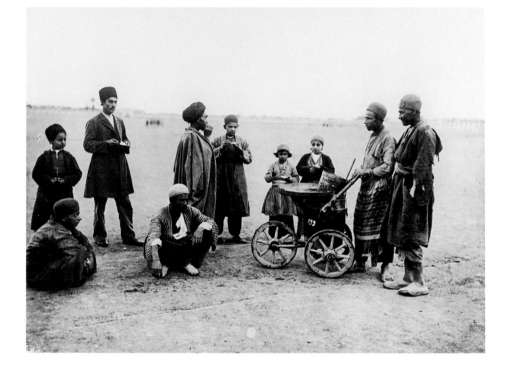

the nucleus of the Henry and Nancy Rosin Collection. These beautifully hand-painted images of architecture, landscapes, studio portraits, and people in daily activities document an era of tremendous social transformation. Iran in the late nineteenth and early twentieth centuries was a subject of great interest to Tehran-based photographer Antoin Sevruguin, who captured images of shahs, Iranian society, public events, and historical architecture. Together, these informative materials preserve and provide significant insight into the art and culture of Asia.

The Ice Cream Vendor, *Myron Bement Smith Collection, photo by Antoin Sevruguin, ca. 1890, Gift of Katherine Dennis Smith, 1973–85, Freer Gallery of Art and Arthur M. Sackler Gallery Archives, A0780.*

Library

"The ample study rooms and the varied nature of the collection to go into the Freer unit will attract scholars from distant countries as well as from far away points in the United States, and it could, I believe, become eventually, a very valuable educational asset."

Charles Lang Freer, letter to [Smithsonian] Secretary Walcott, September 9, 1919

The Library of the Freer Gallery of Art and Arthur M. Sackler Gallery originated as a collection of four thousand monographs, periodical issues, offprints, and sales catalogues that Charles Lang Freer donated to the Smithsonian Institution as part of his gift to the nation. With more than eighty-six thousand volumes, the Library now is considered one of the finest repositories of Asian art resources in the United States. Since it opened in the Freer Gallery in 1923, it has shared the Smithsonian's mission for the "increase and diffusion of knowledge," while its specific purpose is "to foster and stimulate study of the artistic traditions and cultures of the peoples of Asia." We achieve these missions by maintaining the highest standards for collecting materials relevant to the history of Asian art and culture through an active program of purchases, gifts, and exchanges.

Bookbinding cover, Egypt, 14th century, Freer Gallery of Art, F1945.15.

Seven Young Women
in a Bamboo Grove,
Kawamata Tsunemasa
(Japanese, active 1716–48),
Japan, 18th century,
Freer Gallery of Art,
F1898.424.

In July 1987 the Library moved to its new home in the Arthur M.
Sackler Gallery and in 2000 became a branch of the Smithsonian
Institution Libraries. Today it supports activities of both museums, such as
collection development, exhibition planning, publications, and other
scholarly and educational projects. Its published and unpublished
resources—in the fields of Asian art and archaeology, conservation,
painting, sculpture, architecture, drawings, prints, manuscripts, books,
and photography—are available to museum staff, outside researchers,
and the visiting public. About half of the collection consists of works
in Chinese or Japanese. While the Library's predominant focus is on
Asian art and archaeology, it also includes publications about American
artists who were active in the late nineteenth and early twentieth
centuries and whose works are in the Freer Gallery of Art.

Four Evangelists,
Egypt, 1175–1200,
Freer Gallery of Art,
F1955.11.

Chronology

Freer Gallery of Art

1854 On February 25, Charles Lang Freer born in Kingston, New York

1883 Becomes vice president and secretary of Peninsular Car Company
in Detroit
Begins collecting European prints

1887 Acquires works by James McNeill Whistler (1834–1903)
and a small Japanese fan attributed to Ogata Kōrin (1658–1715)

1893 Lends American paintings to World's Columbian Exposition
in Chicago and purchases first piece of Chinese art, a small
painting of white herons from the Ming dynasty (1368–1644)

1894 Begins yearlong trip around the world, which includes first visit
to Asia, stopping in Ceylon (now Sri Lanka), India, China,
and Japan

1904 Purchases Whistler's *Harmony in Blue and Gold: The Peacock Room*
Offers the Smithsonian his art collections and funds to build
a museum

1906 The United States government formally accepts Freer's gift
on January 24

1912 Lends selection of objects for exhibition at Smithsonian Institution

1913 Commissions Charles Adams Platt (1861–1933) to design
museum building in Washington, D.C.

1919 Freer, age 66, dies on September 25 and is buried in Kingston,
New York

1923 Freer Gallery of Art opens to the public on May 9

Arthur M. Sackler Gallery

1913 On August 22, Arthur M. Sackler born in Brooklyn, New York

1937 Graduates with an M.D. from New York University School
of Medicine

1938 Establishes Laboratories for Therapeutic Research in New York

1930s Begins collecting American and European art

1949 Founds the Creedmoor Institute of Psychobiological Studies
in New York

1950–62 Editor of the *Journal of Clinical and Experimental Psychopathology*
Begins collecting Asian art, eventually acquiring the world's
largest collection of Chinese art

1960 Founds the biweekly *Medical Tribune* newspaper and serves
as publisher

1965 Creates the Arthur M. Sackler Foundation to ensure that scholars
and the general public have access to his collections of Asian
and European art

1970s–80s Endows galleries at the Metropolitan Museum of Art and
museums at Harvard University and Beijing University

1982 Provides $4 million and key objects from his collection to form
the Arthur M. Sackler Gallery at the Smithsonian Institution

1987 Sackler, age 73, dies in New York on May 27
Arthur M. Sackler Gallery, designed by architect Jean-Paul
Carlhian (b. 1919), opens to the public in September

Freer Gallery of Art

KEY

1, 2	South Asian Art
3, 4	Islamic Art
5, 6, 6a, 7, 8	Japanese Art
9	Korean Art
10, 11	American Art
12	The Peacock Room
13, 14, 15, 18	Chinese Art
16	Freer and Egypt
17	Buddhist Art
19	Special Exhibitions

↑↓ Elevator
i Information

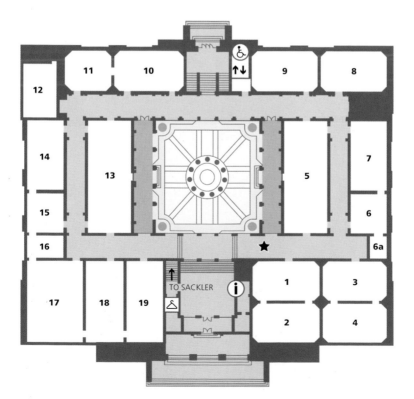

Arthur M. Sackler Gallery

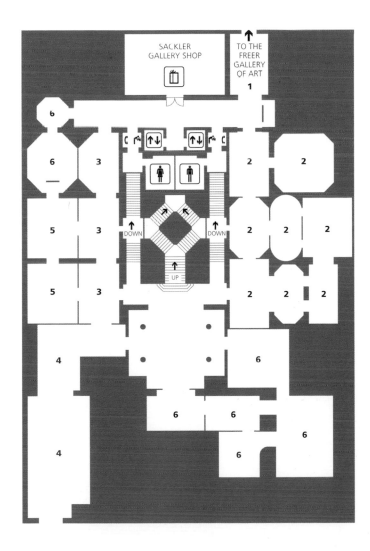

Contributors

Joseph Chang
Louise Allison Cort
Debra Diamond
Nancy Eickel
Massumeh Farhad
Lee Glazer
David Hogge
Carol Huh
Jane Lusaka
Blythe McCarthy
Keith Wilson
Ann Yonemura
Reiko Yoshimura

Photo Credits

Photographs (except where noted) by
John Tsantes, Neil Greentree, and Robert Harrell,
Department of Imaging and Photo Services,
Freer Gallery of Art and Arthur M. Sackler Gallery

Index

Page numbers in italics refer to illustrations